IMAGES
of America

PERINTON AND FAIRPORT
IN THE 20TH CENTURY

This book is dedicated to William Matthews (1925–2003).
His bringing together of local historians in 1996 and his
encouraging of the Perinton Historical Society to write a history
of our community helped make this book possible.

IMAGES
of America

PERINTON AND FAIRPORT
IN THE 20TH CENTURY

Perinton Historical Society

ARCADIA

First published 2004

Published by Arcadia Publishing,
an imprint of Tempus Publishing Inc.
Portsmouth NH, Charleston SC, Chicago,
San Francisco

Printed in Great Britain

Library of Congress Catalog Card Number: 2003104548

For all general information, contact Arcadia Publishing:
Telephone 843-853-2070
Fax 843-853-0044
E-mail sales@arcadiapublishing.com
For customer service and orders:
Toll-free 1-888-313-2665

Visit us on the Internet at www.arcadiapublishing.com

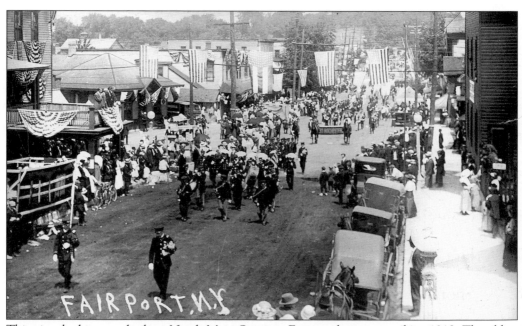

This view looking north along North Main Street in Fairport shows a parade c. 1912. The oldest building in the village, the Fairport Hotel, stands at the far left, and the newest building, the Rochester, Syracuse, and Eastern trolley station, is across the tracks to the right. The horses and carriages at the far right will have vanished in the next several decades, replaced by the automobile.

CONTENTS

ACKNOWLEDGMENTS

Special thanks go to the following people who contributed support and information for the book: Jean Keplinger, Perinton town historian; Sue Roberts, historian; Mary Conners and James Burlingame, East Rochester historians; the Perinton Historical Society Board of Trustees and Executive Committee; Don Santini, Fairport High School Athletic Department; Donald Fox, Fairport Fire Department; Leroy Hokenson, Bushnell's Basin Fire Department; Larry John, Egypt Fire Department; New York State Museum of Transportation; Charles Robinson of the Rochester Chapter of the National Railway Historical Society; William Matthews; Marlene and Sonny Robinson; Earl Pittinaro; Frank Pittinaro; David Lanni; Nadeen P. Walsh; Jeanne and Robert Burger; Seymour and Marilyn Rudin; Marilyn Kriel; Guido Reggi; Connie and Bill Foster; Richard Walter; Richard Steubing; Albert Knapp; James R. McFarlane; Chris Hauf; Maurice and Ann Rasbeck; Cindy Speciale; and Carol Alvut.

We would like to thank the following individuals and organizations for generously allowing us to use their pictures in this publication. The sources are followed by page number and, where two pictures appear on one page, an *a* for "above" and *b* for "below."

Aerial Survey of Rochester (114a); Barstrom and LaCroix Architects (114b); Bushnell's Basin Fire Department (90ab, 91a, 92ab); Carol Alvut (49a); David Lanni (11ab, 14b, 21b, 68b, 113, 120a); Earl Pittinaro (79a, 119a, 126a); East Rochester Department of Local History (12ab, 14a, 15b, 17b, 29b, 30, 31a, 32a, 37b, 51b, 65b, 77a, 79b, 86ab, 87ab, 88ab, 89a, 97ab, 98ab, 99a, 103, 110a); Fairport Fire Department (83ab, 84b, 85b); Fairport High School Athletic Department (96b, 100a, 101a, 102ab); James R. McFarlane (16a); Jeanne and Robert Burger (28); Nadeen Patterson Walsh (24); Pam Lewis (91b); Perinton historian's office (27b, 29a, 33, 34a, 37a, 38b, 40a, 41a, 42b, 46a, 53b, 59, 61b, 65a, 70a, 73a, 85a, 89b, 100b, 106b, 109b, 112b, 121b, 122a); Richard Steubing (22b, 26b, 110b, 111a); Richard Walter (31b); Rochester Chapter of the National Railway Historical Society, Wallace Bradley Collection (10a, 13b, 19ab); U.S. Patent and Trademark Office (43, 45a, 46b, 48a, 49b, 51a, 52b, 53a, 54a, 56a, 57b, 58ab).

Except for those listed above, all images are property of the Perinton Historical Society.

Perinton Historical Society

Joan Alliger
Sharon Catanese
William Keeler
T.C. Lewis
Lucy McCormick
Roger Nelson
Ruth Post
Eileen Mathews Wierzbicki
John Wierzbicki

INTRODUCTION

Today, in the early years of the 21st century, one may wonder what seeds of change are being sown that will have an effect on future generations. Who from the 19th century could have imagined the proliferation of the light bulb, the national obsession with the automobile, commercial air travel, or the computer? Who could have predicted two world wars, Prohibition, the Great Depression, or urban sprawl?

In the beginning of the 20th century, both the nation and this local community were looking toward a bright future. The Spanish-American War had just concluded, and William McKinley had just been reelected as the 25th president of the United States. The World Exposition, displaying the latest in technological advances, had just opened in Paris in 1900. Human speech was being transmitted over radio waves for the first time, and the first flight trials for the zeppelin had just begun.

The population of the nearby city of Rochester was rising and was predicted to be at half a million people in the next few decades. The city had developed from a small village to the hub of population, business, industry, and culture in the region by the 20th century.

In Perinton and Fairport, the DeLand Chemical Company, one of the first manufacturing plants in Fairport, had rebuilt the business after the devastating fire of 1893. The company was in the process of reorganizing, ensuring employment for dozens of workers. The Cobb Preserving Company, having refined the solderless can, was preparing to create a separate division for the manufacture of improved tin cans. The village of Fairport had two rail lines and the Erie Canal, which moved great quantities of local products to markets in New York City and the West. People in the village walked to work and shopped locally. The town of Perinton was made up of small family farms with names like Prospect Farm, Cherry Grove Farm, Sunnyridge Fruit and Berry Farm, and Turk Hill Valley Farm.

Perinton and Fairport began to change with the completion of the Interurban Electric Railroad lines in the early 20th century. Using this transportation system, a traveler could ride the trolley from New York City to the Pennsylvania state line, passing through all the major upstate New York cities.

In 1906, a section of this line known as the Rochester, Syracuse, and Eastern Electric Railroad completed tracks through Perinton. This railroad had 11 stops in Perinton, and a resident could travel from Fairport to the city of Rochester in 23 minutes. Each stop along the route was a potential housing development, and new residential neighborhoods popped up in previously remote locations.

The trolley remained in business for only 25 years, but these new neighborhoods were now connected by a web of roads and the automobile. The increase in population begun by the trolleys and, later, the automobile, brought changes and expansion to local services and schools.

The 20th century also brought with it new innovations that affected the residents of Perinton and Fairport. Local inventors such as Robert Douglas, inventor of Certo, and Willis Trescott, who built fruit-grading machinery, created local jobs. Other companies such as Crosman Arms, Crosman Seeds, the Brainerd Brass Manufacturing Company, and the American Can Company moved to the town and expanded their businesses here.

National decisions and policies affected local life. War brought its own set of challenges, and people of this community had to cope with rationing, home security, and sending their sons, daughters, and husbands to protect the nation. Urban renewal had a dramatic effect on the central business district in the village of Fairport. The federal policy at the time, carried out by the Urban Renewal Agency, was to raze whole blocks of older buildings and replace them with modern structures to stimulate local economies. The razing of the heart of the village in 1977 was a dramatic visual and economic change for the community.

The 21st century brings with it new hopes and experiences for this western New York community. Although the future cannot be predicted with any degree of accuracy, the community surely will be able to handle new challenges as well as it has those of the past.

—William Keeler
October 26, 2003

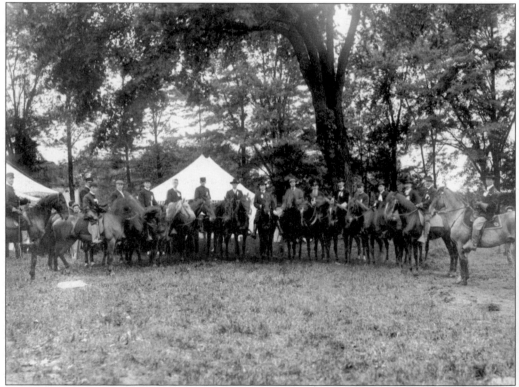

One of the first festivals of the 20th century in Fairport was Old Home Week, August 2–8, 1908. An estimated 45,000 to 85,000 people attended this week-long event. Here, the riders are gathered to lead one of several parades that were held during the week. Civil War veteran Eugene Bortle, believed to be the 11th rider from the left, led the parade down Main Street.

One

THE ROCHESTER, SYRACUSE, AND EASTERN RAILROAD, 1906–1931

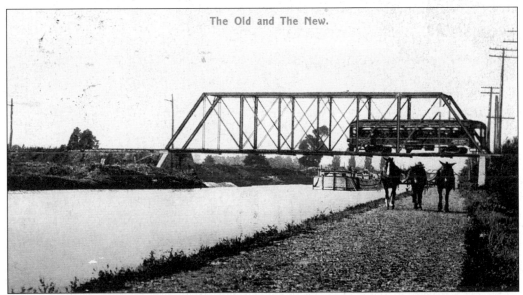

The Old and The New.

This postcard, entitled *The Old and the New*, shows the 19th-century reliance on horses, mules, and the canal for transportation and also illustrates the coming of the machine age, with the fast-moving trolley passing overhead. Ironically, before the middle of the 20th century, another machine, the automobile, would replace the trolley in western New York and much of the nation.

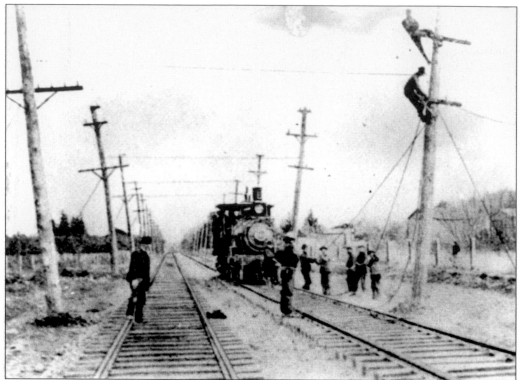

When the Rochester, Syracuse, and Eastern Electric Railroad was completed in 1908, it was one of the most expensive trolleys in the country. The 87-mile line cost $7 million. What made the trolley so expensive was its double tracks, one for outbound trolleys and one for inbound ones. During construction, steam engines were used to keep the trolley cable taut while running the overhead lines.

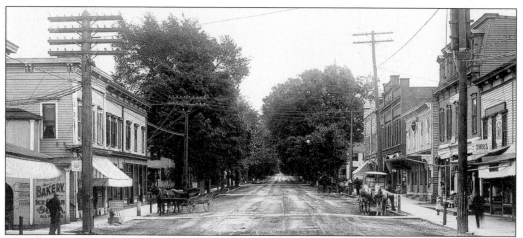

Many electric trolley companies were formed in the early 20th century, each spurred by the potential earnings from this new form of transportation. Companies competed with one another to win franchises through villages and cities. The Monroe County Electric Belt Line won the right to lay tracks through the village of Fairport in 1901 by agreeing to route its trolley along the central business district on South Main Street. The company later went bankrupt and was bought out by the Beebe Syndicate, which never used these tracks.

The Beebe Syndicate, chartered in 1901, raced to complete its trolley in 1906 so that its investment would begin to yield a return. The company, when it bought out the Monroe County Electric Belt Line, assumed that the franchises through the village of Fairport were intact. However, when they began to lay tracks on John Street, the village demanded that the Beebe group reapply for the franchise and arrested 21 laborers who refused to stop working.

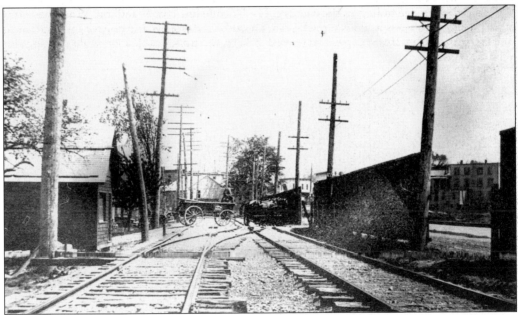

The trolley, which traveled east and west through the village of Fairport, was located between the New York Central tracks and the Erie Canal. The canal authorities built an eight-foot-high wooden fence between the towpath and the trolley tracks "to keep the cars from frightening the mules on the tow path and the boat crews from frightening the passengers on the trolley." (*Perinton's Heritage 1812–1962*.)

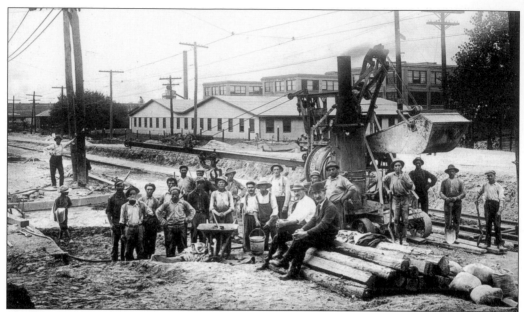

The Beebe Syndicate was a privately owned company that secured private rights of way from individuals, with the exception of street operations in the villages and cities. The company had to agree to maintain the area between the tracks that were constructed along urban streets. This cement truck can be seen here in 1905 on Commercial Street in Despatch, with the Foster-Armstrong Piano Works in the background.

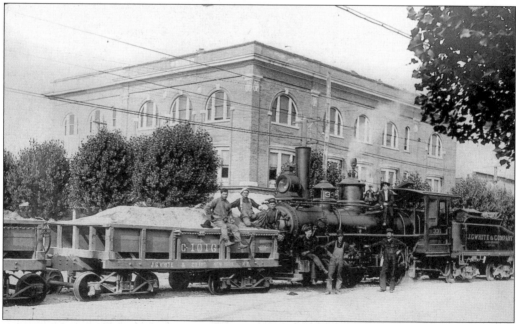

During construction, a temporary skeleton track was laid on one side of the double-track subgrade and was used to haul gravel, ties, and rails to the construction site. A track connection for materials coming from distant distributors was established with the West Shore Railroad at stop 12. The Egypt Gravel pits near stop 18 provided gravel for the project. Seen here is the construction site in front of the Eyer Block in Despatch.

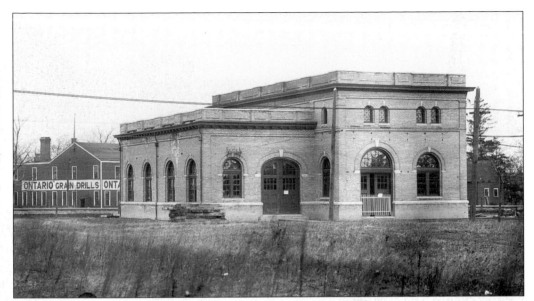

In 1906, when part of the trolley line was first in operation, all power was generated from a large steam station east of Lyons, New York. Substations were built along the line to step down the voltage for use by the trolley cars. The Despatch substation (which is still standing) was located on East Chestnut Street. The Ontario Grain Drill Company, makers of mechanical seed drills, can be seen in the background.

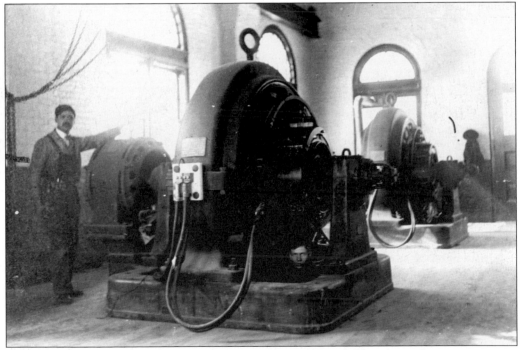

Inside the substation, rotary converters changed the incoming high-voltage alternating current to 600 volts of direct current, which was then transmitted through feeders to the trolley wires. The power was then picked up by a wheel, or "trolley," atop a pole on the car's roof. The speed of the car was regulated by the motorman through a controller box.

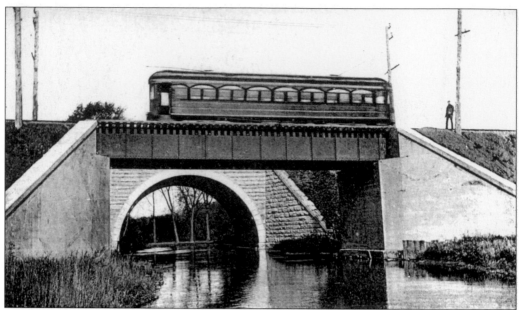

As the trolley line was built through the villages of Despatch and Fairport, the route paralleled the previously established railroad tracks. A large earthen embankment, which changed the course of Irondequoit Creek, was needed to raise the grade of the tracks for spanning the creek. This plate girder bridge can be seen crossing Irondequoit Creek in what is now Eyer Park, with the stone railroad overpass in the background.

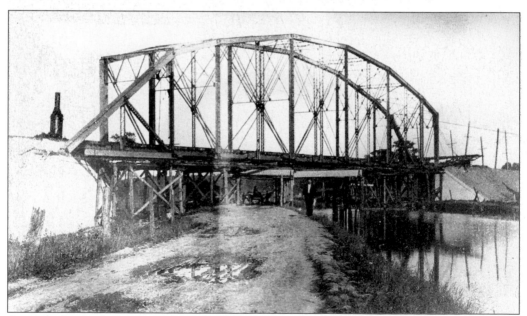

Open girder bridges, like this one being constructed over the Erie Canal near the Cobb Preserving factory, were used for spans over 80 feet. These bridges were designed to carry the weight of two three-car trains passing each other at 60 miles per hour. Periodic inspections were done by company bridge inspectors and later by independent engineers.

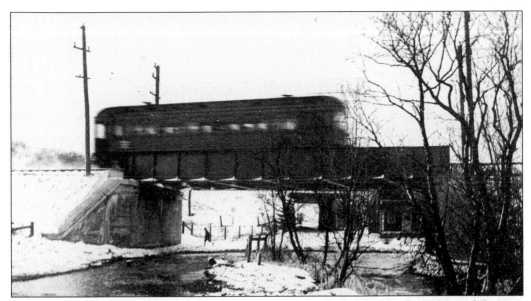

The trolleys offered their customers speed and reliability. The Rochester, Syracuse, and Eastern, also known as the "On Time Line," brought workers into the city from Fairport in 23 minutes. Even the flood of 1916, when Thomas Creek overflowed its banks near Baird Road and appeared to be undermining the bridge abutments, could not stop the regular trolley runs to the city of Rochester.

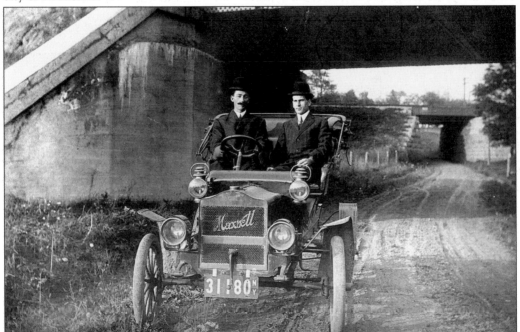

As the first Rochester, Syracuse, and Eastern car was leaving the station in 1906, the fate of the trolley was being determined by the automobile. In the next few years, automobiles became more frequent on the roads and more affordable to the working man. This Maxwell is seen traveling along Baird Road and has just passed under the railroad bridge in the background and the trolley bridge in the foreground.

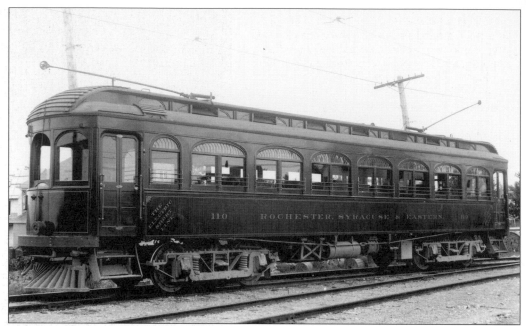

Initially, all the cars built by the Niles Car Company for the Rochester, Syracuse, and Eastern were made of wood. They measured from 45 feet (the "short car") to 56 feet (owner Clifford Beebe's private car) in length. All of the cars were double ended so they could operate in either direction. Car No. 110, built in 1906, was 53.5 feet long and seated 58 people.

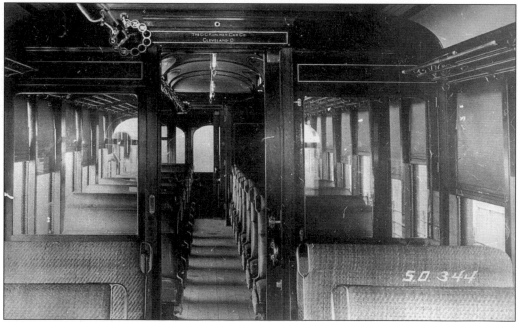

The "club cars for the masses" were equipped with leather seats in the main compartment and cane seats in the smoking area. A sliding door separated the smoking area. No one under 15 was allowed in unless accompanied by an adult. The motorman rode in the front; passengers entered and exited from the rear. Two attempts were made to make the cars more attractive by introducing the plush parlor car in 1915 and the chair car in 1927.

Each trolley car had a conductor (left) and a motorman (right). When the train was two cars long, a system of bells and buzzers was used to communicate between the motorman and the conductor. There was a special short line that ran between the village of Fairport and the city of Rochester and was especially designed for workers commuting to and from the Rochester station on Culver Road and the Fairport station on North Main Street.

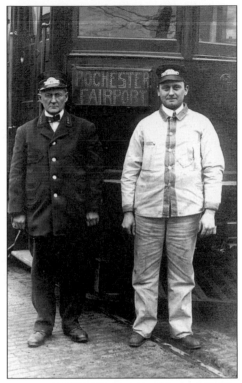

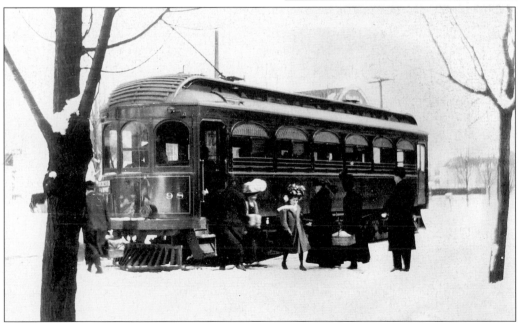

These women with period hats, c. 1910, are disembarking from car No. 98, called a "stub car," along East Commercial Street in East Rochester. The cars, built in 1906, were 45 feet long and seated 46 passengers. They were used mainly for local routes. The longer cars ran on "limited" assignments, were capable of speeds of 65 miles per hour, and stopped only in the cities and large towns.

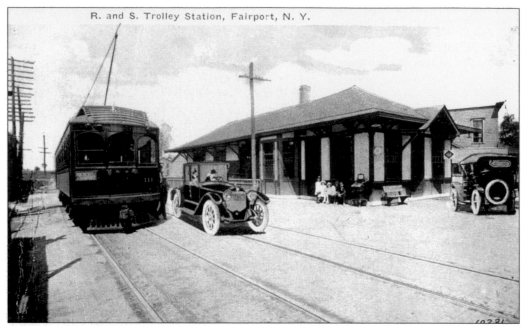

R. and S. Trolley Station, Fairport, N. Y.

The Fairport station was built in 1911 on land previously occupied by Boyland Mills. It had a heated waiting room that seated 34 people. From 1906 to 1911, tickets could be bought at the Sugar Bowl restaurant across the tracks. The Rochester, Syracuse, and Eastern became part of the Empire United Railways in 1913. It changed its name and ownership back again in 1916 and then became incorporated as the Rochester and Syracuse Railroad in 1917.

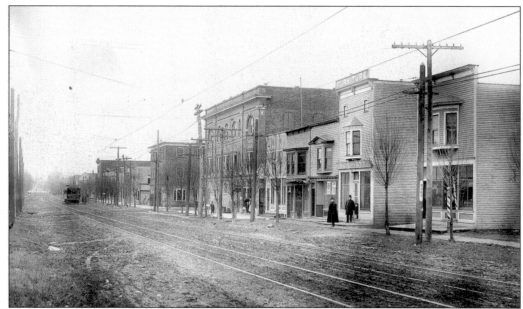

The trolley ran through Despatch's main business and industrial district on Commercial Street. The first station was located in the Candy Kitchen on East Commercial Street. Later, the station was moved to a wooden building at 108 West Commercial Street and was operated by Phil Hager and his wife, Augusta.

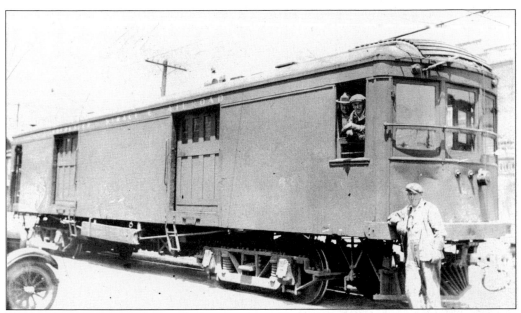

The trolley was designed primarily for passengers. Due to the difficulty in obtaining operating rights in Rochester, freight service did not really prosper until 1911. Typical freight was milk, produce, newspapers, and mail. The only industrial siding in use was at the Egypt Canning Company factory near stop 18 in Egypt. Coupling equipment was designed so that the freight cars could be attached to cars from other trolley lines.

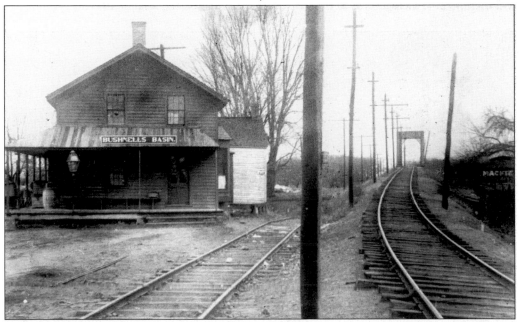

Perinton was also served by the Rochester and Eastern Rapid Railway from 1904 to 1930. This 44-mile, single-track line ran from Rochester to Geneva, New York, with a station in Bushnell's Basin. The Rapid Railway proved its name in 1904, when an electric car beat the New York Central and Hudson steam train in a race along a straight stretch of track just west of Victor, New York.

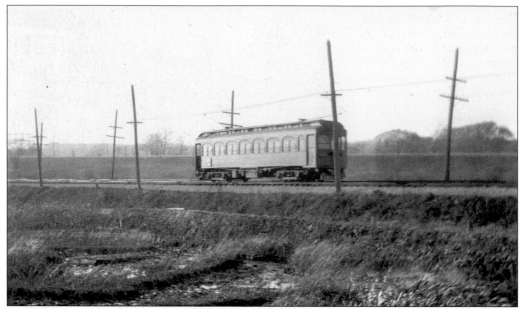

Trolley cars operated at speeds approaching 70 miles per hour in the open spaces between towns and villages. In 1920, a man was struck and killed near stop 12 on Fairport Road along this set of tracks. Two weeks after the accident, an article appeared in the local newspaper announcing a change in the color of the cars from dark green and blue to "traction orange" for better visibility. In 25 years of service, no passengers were killed while riding on the trolley, but there were fatalities among those unfortunate enough to be crossing the tracks at the wrong time.

In 1915, a westbound trolley hit an automobile driven by Rev. Frank Kenyon (left) at a crossing by stop 16 on Ayrault Road. C.C. Moore (right) was the only survivor. Passengers Elizabeth Bort and Robert Gray were killed in the accident. Kenyon had stopped the automobile for one westbound trolley and proceeded slowly, checking the eastbound tracks, when a second westbound trolley rounded the curve and collided with the automobile.

Vincent T. Kennelly Sr., who lived at 88 Roselawn Avenue, was employed by the Rochester, Syracuse, and Eastern for 17 years. He was a traveling freight agent for 12 years, a dispatcher at the Newark office, and a conductor for 5 years. Vincent Kennelley Sr., shown in his conductor's uniform, was aboard the last trolley that ran through Fairport. Vince Kennelley Jr., standing in front of his father, later became a beloved mayor of the village of Fairport.

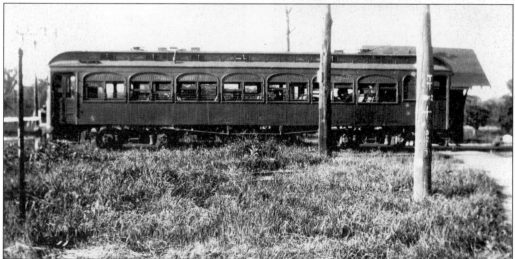

This photograph is believed to be of car No. 122 on its last trip on the old Rochester, Syracuse, and Eastern line in Egypt, New York. The motorman was Eugene Terbush of Rochester. The conductor was Thomas Slater of Newark, and the spare conductor was Vince Kennelly Sr. of Fairport. This car, named the *Rochester*, had been refurbished in 1927 into a chair car in an attempt to regain passengers.

NOTICE

•

All Service will be abandoned on this Railroad after the last car to-night.

June 27-1931

•

Notices were posted in trolley stations along the now incorporated Rochester and Syracuse Railroad route on June 27, 1931, marking an end to trolley service in Perinton. The electric cars that had "thundered like juggernauts over the street" for a quarter-century were silenced by the motorbus and private automobile. The first Greyhound bus left the following morning at seven o'clock along the route formerly operated by the trolley.

The last physical evidence of the Rochester, Syracuse, and Eastern, the steel structures, were removed in 1942 for scrap. The Baird Road bridge was sold to William T. Jackling and Sons at public auction for $1,200. The bridge contained 25 tons of steel, which was used for the war effort. Even though the physical presence of the trolley is no longer with us, the effects of the trolley, which opened up the rural regions of western New York and made them more accessible to people, are still being felt today.

Two
Trolley Neighborhoods

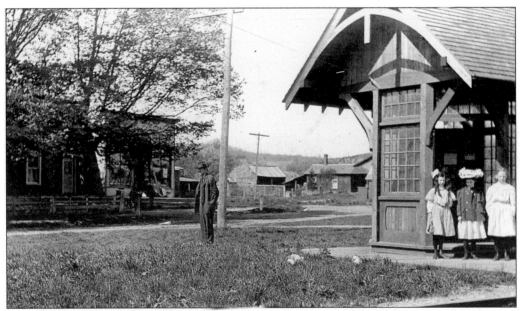

The Rochester, Syracuse, and Eastern had 11 stops in Perinton: 2 stations and 9 stops located on country crossroads. These stops linked older communities and created new ones in the town. The hamlet of Egypt, founded in the early 1800s along a stagecoach route, was stop 18. The distinctive octagonal waiting station with the large overhanging roof was specially designed for the trolley. Woolsey's store, later known as Nelson's store, can be seen in the background across the street.

Carl Fredrick Wilhelm Patterson bought the 28-acre Sunnyridge Fruit and Berry Farm, on Baird Road, in 1906. The site would become one of the first residential subdivisions in the town of Perinton. That same year, the Rochester, Syracuse, and Eastern constructed stop 11 near the New York Central tracks, several hundred feet from the property. Patterson, born in Germany in 1862, was a carpenter who began building houses on the street one at a time. As each house was completed, he and his family (his wife, Louisa Martz, and their four sons) would move into the newly completed house and sell the old one. The family is believed to have moved four times on Baird Road from 1906 to c. 1915 before they left the neighborhood.

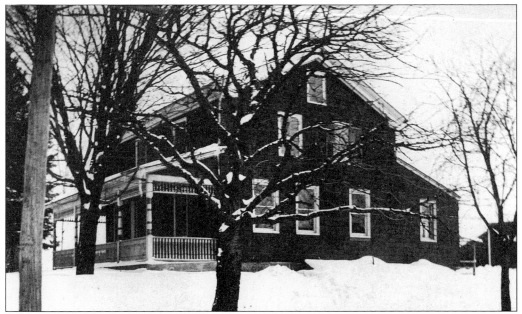

The first house the Patterson family moved to was at 2758 Baird Road, one of only four houses on the street between the trolley underpass and Rochester Road. This house is believed to have been erected by the pioneers from the Northrop settlement c. 1810. After the completion of the new house across the street, this house and 25 acres were sold in 1909 to Louis Dannenburg, who grew cut flowers. The house was razed c. 1969.

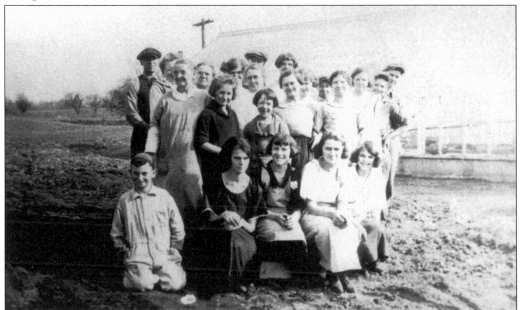

In 1912, the first house Carl Patterson built was sold to Herman Steffen, a market gardener from Irondequoit. Herman's brother George Steffen (pictured here in the back left with his work crew c. 1923) bought the farm and raised chrysanthemums and tomatoes in the many greenhouses on the property. George Steffen raised over 300,000 tomato plants a year and sold them to local farmers in Monroe and surrounding counties.

Houses built by Carl Patterson were small and affordable. The Norman House, at 2737 Baird Road, is believed to have been the last of the Patterson-built houses. Arnold Norman worked as a brakeman on the Baltimore & Ohio Railroad and later became a house painter. There was a large chicken coop off the back of the house. Norman's daughter Ruby would collect the eggs daily and ride the trolley into the city to sell them at the market.

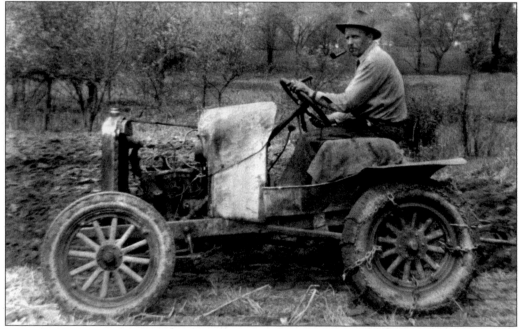

Julius Steubing was a member of the second generation of Steubings to live and farm the property of the former Jefferson Mill, at 2725 and 2729 Baird Road. The Steubings raised strawberries and tobacco in the valley where the dam and millpond once stood. People from the city would come in early summer, by trolley and automobile, to pick strawberries and attend "strawberry socials" on the hill overlooking Thomas Creek.

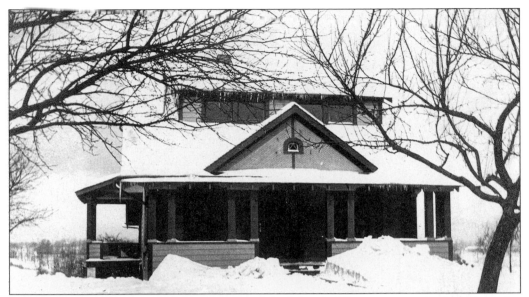

This bungalow-style house at 2753 Baird Road, built by Carl Patterson, was the last house the Patterson family lived in. In November 1913, Patterson suffered a fractured skull when a chimney fell on him while he was working to repair the roof of the Monroe County Mail building on West Avenue, which had been damaged in a fire. He recovered from his injuries and is believed to have built one more house on Baird Road before leaving the neighborhood.

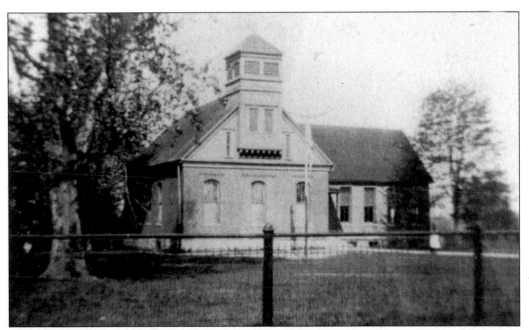

Built in the 1880s, the Midvale School, seen here c. 1920, was the center of community life in the neighborhood. The District No. 2 school served grammar school children of Baird Road, Midvale, the Orchards, and later, Forest Hills. The highlight of the year was graduation, which was attended by all the neighbors and featured awards, music, and plays. The school added another wing in 1926 to accommodate the increasing number of children in the area.

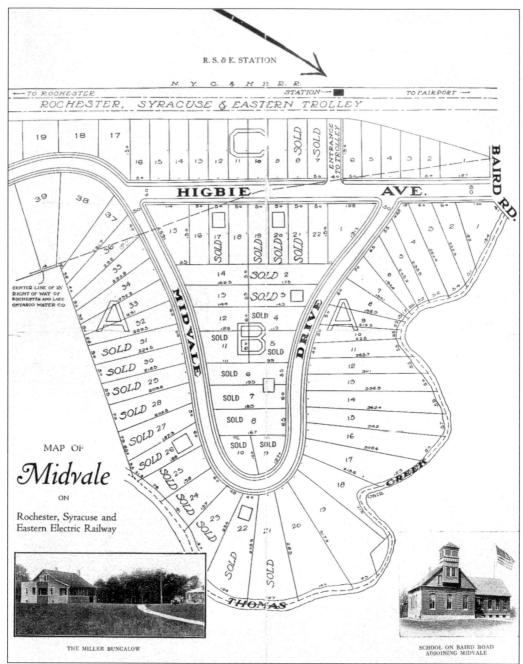

MAP OF

Midvale

ON

Rochester, Syracuse and
Eastern Electric Railway

THE MILLER BUNGALOW

SCHOOL ON BAIRD ROAD
ADJOINING MIDVALE

The Midvale subdivision was one of three bungalow communities marketed by the L.D. Woodworth Real Estate Company. The company would work with owners who had land near a remote trolley stop to subdivide the property and sell lots to prospective homeowners. George Higbie bought the 50-acre farm located just across the creek from the thriving community of Despatch *c.* 1902. The Rochester, Syracuse, and Eastern built a shelter and established stop 11 at the eastern end of Higbie's property, near Baird Road. Higbie built two streets, several model homes, and offered free trolley tickets for people from the city to tour the grounds. Lots were sold from $350 near the creek to $800 on higher ground in the center of the development.

The house on lot 20 on Higbie Avenue, the headquarters for the real estate salesmen, was located opposite the trolley shelter. Potential buyers would be escorted around the parklike streets and would be told about the subdivision restrictions, which included no sale or manufacture of wine and no keeping of swine on the premises. Higbie's son Homer lived three lots down from this house and was the first resident to regularly commute by trolley from Midvale to his father's seed business in the city of Rochester.

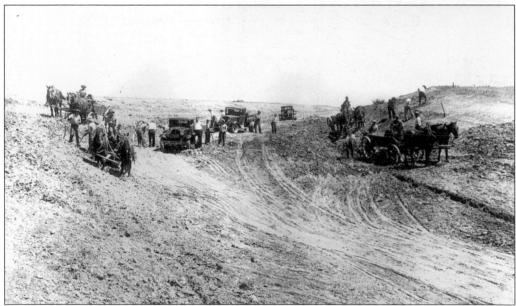

In February 1907, George Higbie offered to donate land on his property parallel to the trolley tracks to the town of Perinton, provided that the town build a bridge across Irondequoit Creek and a highway linking the business districts of the villages of Despatch and Fairport. The town turned him down. After Higbie died in 1931, his son Homer Higbie graded a road in 1933 that connected Midvale with the southern tip of the village of East Rochester, formerly known as Despatch. The road is now abandoned.

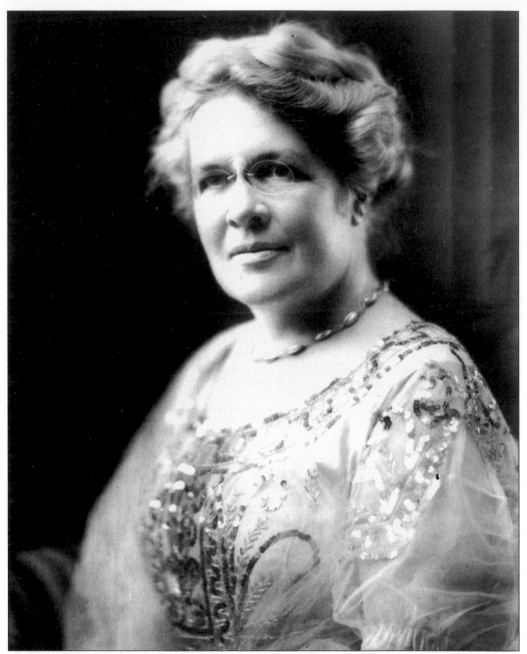

One of America's earliest planned industrial suburbs, East Rochester was a major stop on the Rochester, Syracuse, and Eastern trolley line. Kate Gleason (1865–1933) was a business leader in this village following her 1913 early retirement from Rochester's Gleason Works, where she had been an engineer, salesperson, and businesswoman. Real estate investor Harry C. Eyer, who founded the First National Bank of East Rochester in 1911, asked Kate Gleason to serve on its board. One of the first American women to serve as a bankruptcy receiver, Gleason saved the Ingle Machine Company and made it profitable by 1917. When Eyer went off to war, Gleason became bank president. After the war, she built two distinctive housing tracts called Concrest and Marigold Gardens near trolley stop 10.

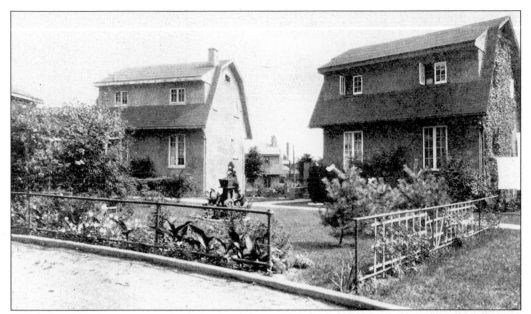

In 1919, Kate Gleason conceived the idea of constructing a local housing community called Concrest, patterned after houses she saw in France on her visits there in the 1890s. A practical house-building experiment was developed by Gleason, which led to the manufacturing of poured-concrete houses near trolley stop 10. She bought materials in quantity, hired unskilled workers, and offered the houses for sale for as little as $3,600.

Designed by Kate Gleason as part of a single development with Concrest, the larger concrete houses to the northwest became known as Marigold Gardens. The houses in this community were promoted in a 1923 booklet as Ellen McDermot Cottages, named after Kate Gleason's mother. These cottages came with a garage, a fireplace, and a sun parlor. Kitchens had a gas range with an oven, as well as an icebox handily located so that "the iceman can fill the box without tracking up the house."

One of the last Rochester, Syracuse, and Eastern trolley cars in East Rochester was used as a private residence. It stood at 328 East Chestnut Street until *c.* 1970, when it was destroyed by fire. Another car (not pictured) was used as a diner in East Rochester's central business district.

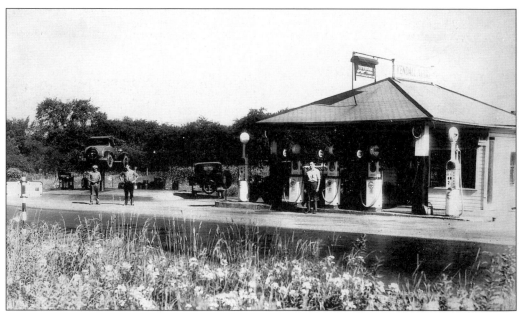

Pressure from automobile owners led to the paving of many local roads. Service stations were constructed to meet the needs of this popular form of transportation. This is Fred Kettler's gas station, which opened up along with a hot dog stand on the west corner of Baird and Rochester Roads in 1925. This was one of two service stations located at the end of Baird Road.

Three

THE PRE-TROLLEY ERA

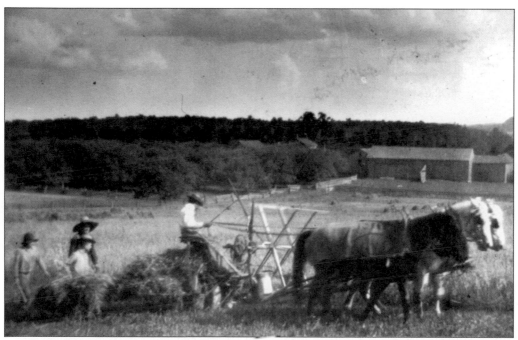

Perinton, like many upstate communities, remained primarily an agricultural region well into the 20th century. The pace of life was slow, but it was being slowly but surely changed by the coming of the Erie Canal, railroads, trolleys, and eventually the automobile. Horses were used on the farm in the 19th and the early 20th centuries. This horse-drawn reaper is being used on a local farm in Egypt *c.* 1900.

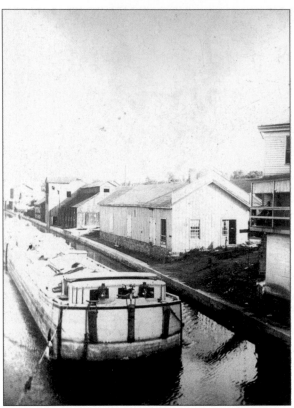

The Erie Canal passed through the town of Perinton. It dramatically reduced the cost of shipping products from $100 a ton by wagon in 1817 to $8 a ton by canal in 1825. Horses and mules were used to tow barges on this section of the canal until, as part of the canal reconstruction, the wooden towpath under the Main Street bridge was removed in 1918. This barge is being towed past the old Hawkins Block (right), which was located on the east side of South Main Street on the south side of the bridge.

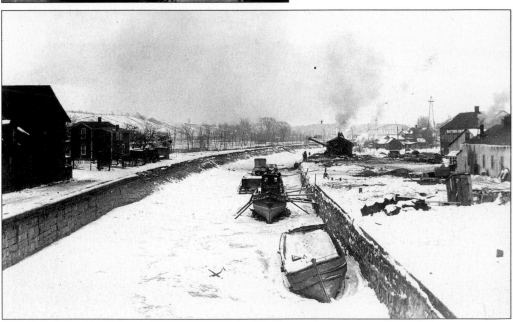

In the early days of the Erie Canal, navigation continued until the canal froze over. Families would sometimes travel together on these boats. When the boat was frozen fast, they would live in their barge and send their children to the local schools. This is a scene of the Erie Canal in winter, seen from the Parker Street bridge looking east.

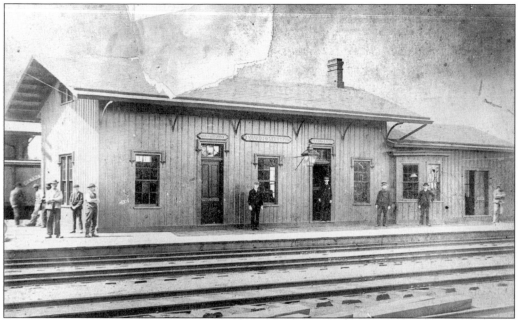

The New York Central passenger station, built in the late 1800s, was located off North Main Street, just across the street from a 50-foot shed holding cords of wood that supplied the steam engines with fuel. There was also a large brick tower, which held water for the engines. The station provided a separate waiting room for women, away from the cigar smoke and spittoons found in the men's waiting room.

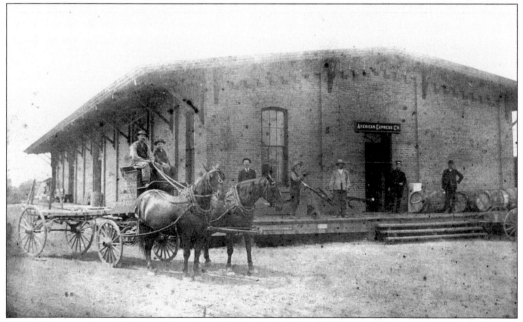

With the coming of the railroads to Fairport in the 1850s, products were shipped more frequently by the faster rail lines. The American Express Company set up an office in the New York Central depot on North Main Street in Fairport. In this c. 1890 view, a wagonload of barreled saleratus soda has just been unloaded by a crew from the DeLand Chemical Works.

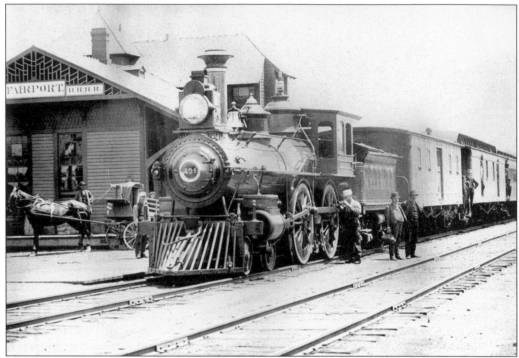

In 1852, the West Shore Railroad laid tracks through Fairport that ran parallel to the New York Central tracks to the north. The station was used by the New York Central after it bought out the West Shore Railroad. Commuters to the city of Rochester would put their bicycles on racks in a special rail car and retrieve them at the city railroad station so they could pedal to work.

Before the trolley, railroads brought Fairporters to cultural and educational opportunities in the city. Ida Dougherty grew up at 199 South Main Street in the village of Fairport in the 1890s. As a high school student, she traveled by railroad to take art classes at the Mechanics Institute of Rochester. After graduation, she studied under illustrator Howard Pyle in his first classes at the Brandywine School in Wilmington, Delaware. Ida's first commission was a stained-glass window depicting the Marriage at Canaan for a cathedral in Milwaukee, Wisconsin.

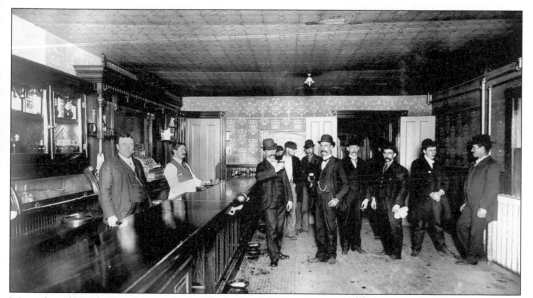

Many hotels and saloons were located on North Main Street to cater to passengers on the canal and, later, the railroads, beginning in the early 1800s. The Kirkwood hotel was one of five hotels and five saloons in Fairport with liquor licenses in 1905. The hotels and saloons supplied food, drink, and lodging for travelers as well as for local residents. Because of the concentration of bars, the area near the tracks was often referred to as "Whiskey Flats."

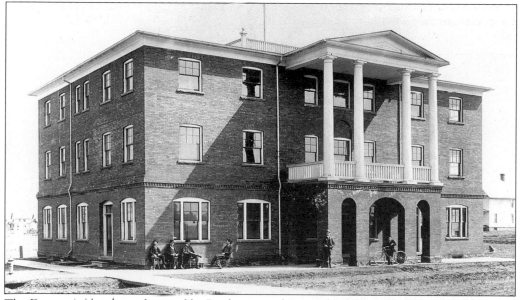

The Despatch Hotel was designed by Rochester architect Claude Bragdon in 1898. There were few homes or rooms available when the new village of Despatch was founded in 1897, so for laborers at the car shops, long-term residency was available at the hotel. The pink-hued brick building was the largest hotel between Rochester and Syracuse at the time it was built. Local lore has it that Harry Houdini performed for a crowd on the Fourth of July in the early 1900s on the front balcony of this hotel.

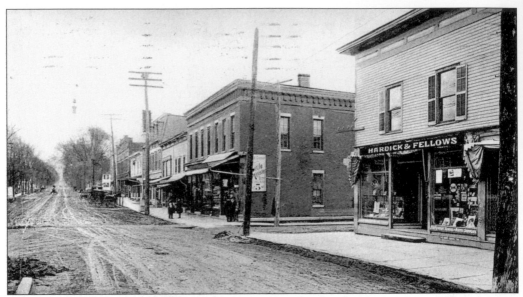

Built in 1850, Jeremiah Chadwick's block (right), on the west side of South Main Street between the canal and West Avenue (center), was a familiar store in the 19th century. The building housed Chadwick's grain store; later, Hardick and Fellows ran a hardware and variety store there. Between 1912 and 1914, the canal was widened. This building was bought by F.F. Schummers and moved in three pieces around the corner to West Avenue. A section of this building stands today at 38–44 West Avenue.

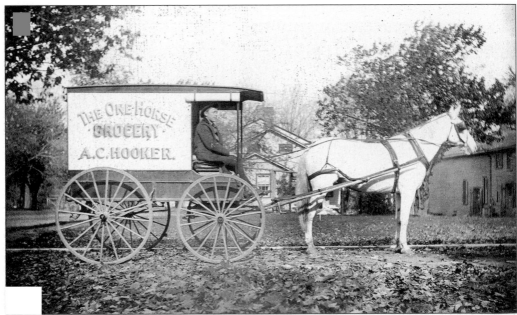

One of several Fairport grocery stores that made home deliveries, A.C. Hooker's One-Horse Grocery was located on West Avenue. The cook or woman of the house could order food in the morning, have it delivered in the early afternoon, and prepare it for the evening meal. Store owners were also known to peddle goods from their wagons on visits to rural farm families.

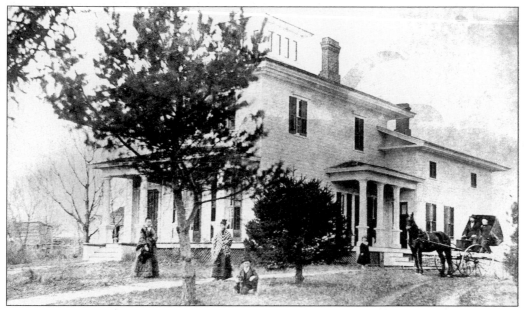

Martin Sperbeck was one of Perinton's first settlers, buying 100 acres of land in 1817. A path from Sperbeck's house, located on top of a hill that overlooked his brother's house on the site of the present Fairport Village Hall, formed what is now South Main Street. In 1870, the front of the house was built in the Italianate style by Martin Sperbeck's son Andrew, who also built the Baptist church on Main Street in Fairport.

Henry Travor (left) and Edward C. Wood (right) made up the business partnership of Wood and Travor and were the owners of the Fairport Mill in the 1880s. Unlike earlier water mills, this was a steam-run roller mill for processing flour. The mill, located on North Main Street, was bought in 1895 by William H. Boyland, who continued to run it until his death in 1935.

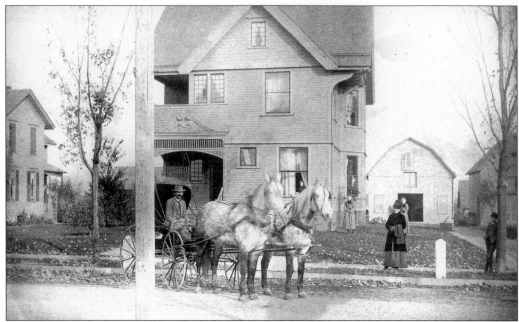

A building boom occurred in the village of Fairport in the late 1880s, as the Cox Shoe Manufacturing Company built its Parce Road plant in 1888 and provided many jobs. The plans for the Nelson Lewis Farm subdivision were submitted the same year that Cox Shoe moved to Fairport. The house at 150 West Avenue in this subdivision was built by carpenter H.J. Wooden for saloon keeper Chester Wilcox and his wife, Rosalie.

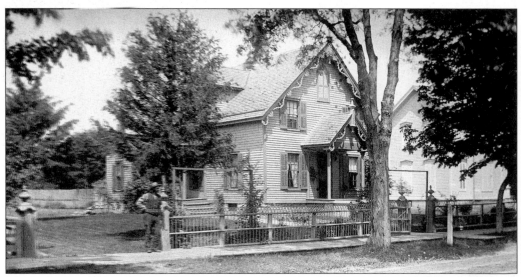

The house at 126 South Main Street was a parsonage for the Fairport Free Will Baptist Church and was occupied by Rev. Freeborn W. Straight in 1852. It was built in the Gothic Revival style, which was popular from the 1840s to the 1880s. The house was later owned by Frank Bown, who worked for his father George in the Bown Carriage Works behind the Bown Block on South Main Street.

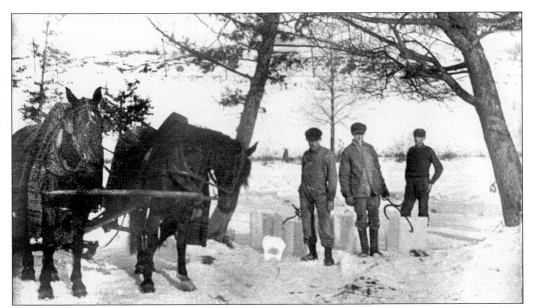

Ice cutting was an important activity on the farm in winter. Farmers would form ponds to harvest ice in January or February. The ice would be cut into large blocks and taken to barns to be stored under layers of sawdust. The ice was used for the family icebox; dairy farmers would use it to keep their milk cold. Seen cutting ice on Crossman Pond are, from left to right, brothers Charles, Lewis, and Richard Matthews.

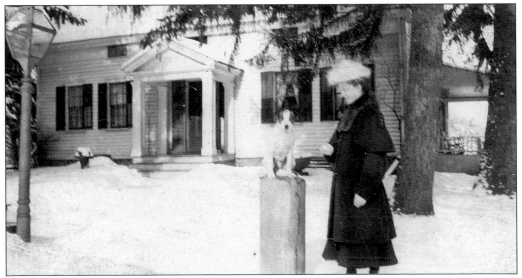

The first frame house built in the town of Perinton was the Ramsdell-Ranney house, in the hamlet of Egypt along the Palmyra-Rochester coach and mail route. Built by Thomas Ramsdell *c*. 1820, the house features both Federal and Greek Revival elements. The Ramsdells, and later the Ranneys, were successful farmers and prominent members of the community. Thomas Ramsdell was overseer of highways and poormaster. Members of the Ranney family served as election inspectors and school trustees for the Egypt District School.

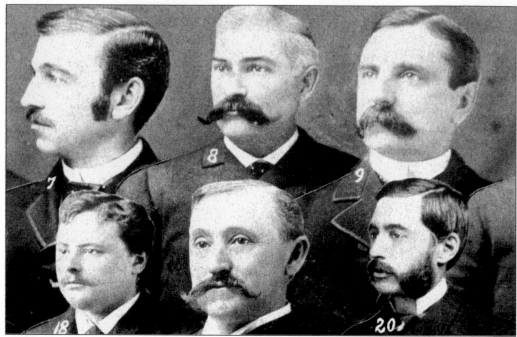

One of the few prominent Democrats of the late 19th and early 20th centuries, Fletcher Defendorf (portrait No. 8) served in the New York State Assembly from 1886 to 1890. He was also president of the village of Fairport and one of the last Democratic Perinton town supervisors, serving in 1890, 1904–1906, and 1914–1918. Two years after he left office, there were only 521 registered Democrats in the town of Perinton out of a total of 6,113 voters.

Horse racing was a popular activity in the 1800s. Races were often held on the ice on the Erie Canal in winter and also down Main Street. Edward J. Cary, owner of the Osburn House, raced his horse both in the village of Fairport and in local races out of town. Cary ran the hotel from 1897 to 1914. The building, located on North Main Street, was demolished in 1938.

Four

THE INVENTORS

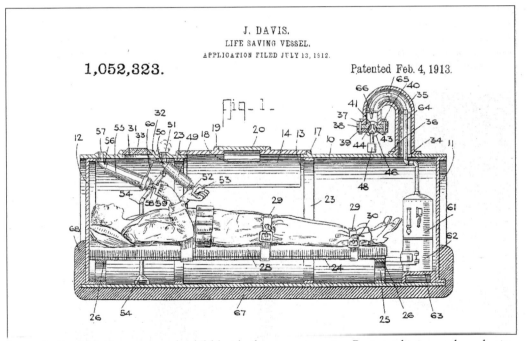

J. DAVIS.
LIFE SAVING VESSEL.
APPLICATION FILED JULY 13, 1912.

1,052,323.

Patented Feb. 4, 1913.

Inventions and inventors are the lifeblood of any community. By introducing and marketing new and original ideas, some inventors brought prosperity and jobs to Perinton, while others were unsuccessful in the marketplace. The lifesaving vessel for ocean liners was invented by Judson Davis, who owned a small notions shop in East Rochester. Davis patented this invention one year after the sinking of the *Titanic*, but no steamship company was interested in his invention because the number and size of the capsules needed for a cruise ship would leave very little room on deck for the passengers.

Joseph Yale Parce and his wife, Lucy Mead Parce, moved from Norwich, New York, to Fairport in the late 1850s. J.Y., as he was known, worked as an engineer with Henry DeLand to improve the efficiency of the DeLand Chemical Company. Two patents held by Parce were designed specifically for the factory on North Main Street. In the 1890s, Joseph and his family followed Henry DeLand to Florida and ran one of the first hotels in the newly formed city of DeLand.

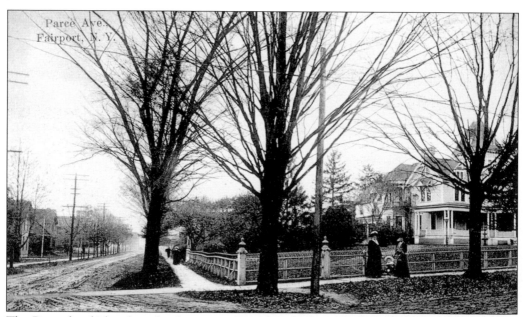

The Parce family lived in this house on the corner of Parce and North Main Streets, on the former 64-acre Dunbar farm. Joseph Parce and a partner bought the farm and established the Parce & Solly Nurseries in 1872. The nurseries were located on several acres behind the house.

The derrick invented in 1859 by J.Y. Parce was the first patent issued to a Fairport resident. The front end of the crane could swing out over a boat, pick up a loaded barrel, and then swing back over the dock. The secret to this invention is the truss system on the side of the crane, which distributed the weight of the load to the entire structure, preventing the front part from twisting.

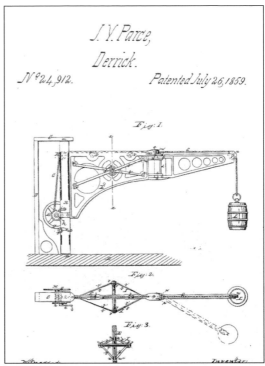

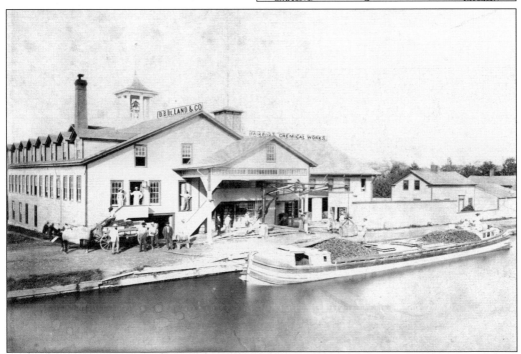

The derrick could hoist a cask five to six feet in diameter, or six to seven ordinary barrels in a rope sling. The DeLand Chemical Company used this derrick to unload limestone and ash from Erie Canal boats for the making of saleratus used in baking. The crane was in use from 1859 to 1893, when fire destroyed the building and dock area.

One of the most prolific inventors in Fairport was Dr. Willis Trescott, with at least seven registered patents. Trescott moved to Fairport in the 1870s and opened a dental practice on South Main Street. He was a partner at Trescott Brothers, an apple dry house in Conesus, New York, and in 1880 established the Trescott Company in Fairport. By 1905, Trescott had closed his dental practice, and he devoted himself to the manufacturing of fruit-drying and grading machines until his death in 1938.

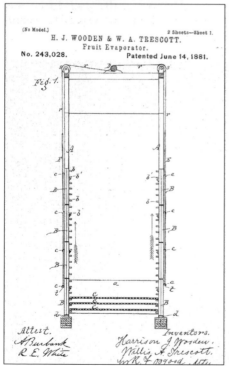

Trescott's first patent, No. 243,028, was a collaborative effort with Harrison J. Wooden, a Fairport carpenter. The two men invented a fruit evaporator that was designed to fit inside a large brick drying chimney. The advantage of this invention was that it took up less floor space than the traditional horizontal drying chambers. The heat from the furnace could be more efficiently used in a vertical oven.

46

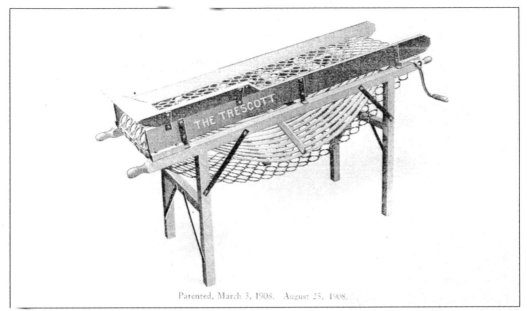

Patented, March 3, 1908. August 25, 1908.

In 1908, Willis Trescott patented two different graders, one for fruit and the other for vegetables. The grader pictured here is a field model and was operated by a hand crank. The basic model cost $35, and powered graders cost $1 extra. The size of the graded fruit was determined by the size of the interlocking links, with the smaller fruits and vegetables falling through the links and being expelled to the side of the belt.

The Trescott factory was located behind the office building at 70 North Main Street, just across from the railroad tracks. The company shipped its machines as far away as California, Canada, and Europe. Berkeley County, West Virginia, boasted of having 130 Trescott machines in operation at one time. A branch office was maintained in Winchester, Virginia, to handle the southern market.

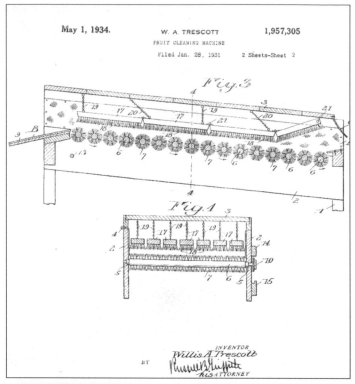

May 1, 1934. W. A. TRESCOTT 1,957,305
 FRUIT CLEANING MACHINE
 Filed Jan. 28, 1931 2 Sheets-Sheet 2

In 1934, with the increased use of pesticides in the fields, Willis Trescott patented this machine, which cleaned and polished fruits. A series of hard-bristled brushes suspended over a conveyor scrubbed the fruit as it made its way to the next station in the packing line. A modification to this machine also took the fuzz off peaches.

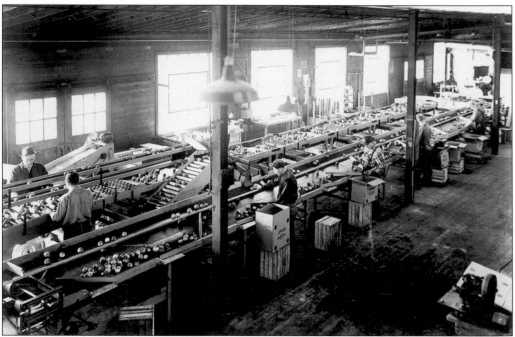

Using a combination of patents, Trescott engineers could customize a packing operation to grade and clean an entire crop of fruit or vegetables into 12 different sizes. In the 1940s, these combinations of cleaning and grading machines were marketed and sold under the trademark Market Makers.

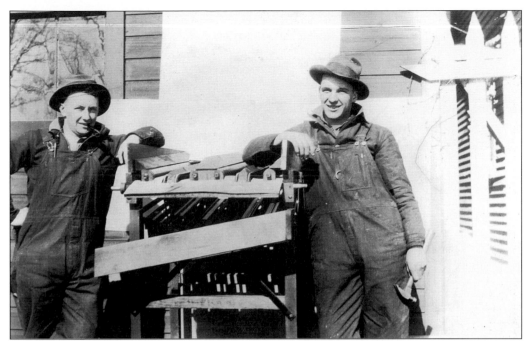

Foster B. Fuller (left) and Arthur R. Adams (right) collaborated with fellow inventor Clarence P. LeFrois in 1938 to patent an improved design in fruit-grading rings. All three worked for the Trescott Company.

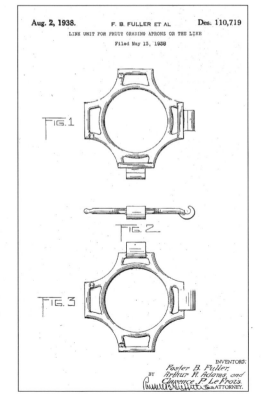

Design patent No. 10,719, a link for fruit-grade aprons, was an improvement over the old links because the cast corners on the links were softer and did not bruise the fruit as easily. Also, the one-piece hooks on two sides of the link eliminated the use of thin metal strips that held together earlier models of the links, saving both time and money.

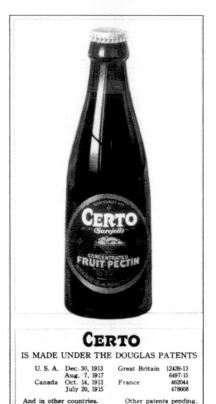

Certo concentrated fruit pectin was manufactured under two patents awarded to Robert Douglas in 1913 and 1917. Douglas invented the process by which pectin found in apple juice could be concentrated through evaporation to produce a syrupy liquid. When mixed with cooked fruit, this product would produce jelly. The word Certo is said to have been coined by Douglas's maid, who said that if a housewife used this product, she was certain to get good results.

Three partners—Robert Douglas, Earl Neville, and John Clinger—bought up a majority share of the New York State Fruit Company in 1911 and absorbed it into the newly incorporated Douglas Packing Company. The company buildings were located on the east side of North Main Street, just across the Main Street bridge in the old DeLand Chemical Company buildings. Certo was manufactured in Fairport until 1947.

Kenneth Brainerd, superintendent for the Brainerd Brass Manufacturing Company of East Rochester, patented a door latch in 1933 that could be used on either right-hand or left-hand doors without any change in the latch. This design also made it possible to open the door by pulling the handle instead of turning or twisting a knob. Kenneth was one of three sons of the founder of the Brainerd Brass Manufacturing Company, William F. Brainerd.

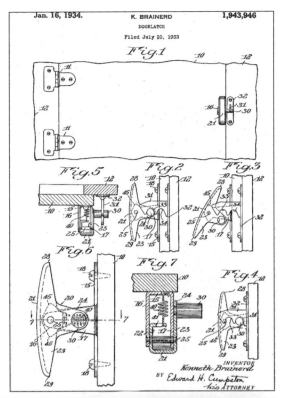

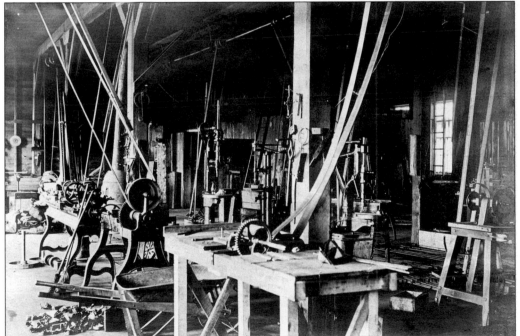

The Brainerd Brass Manufacturing Company made brass handles, hinges, and other hardware. The shop floor had several large overhead shafts that had leather belts attached to pulleys, which ran the presses and polishing machines.

The Crosman Seed House was started in 1838 by Charles Frederick Crosman on Monroe Avenue in the city of Rochester. In 1924, the newly reformed Crosman Seed Company moved to Commercial Street in East Rochester. One of the oldest seed houses in America, the company still sells vegetable and flower seeds in stores throughout the country. Crosman Seeds sells seeds under its own name and has also produced seeds for Montgomery Ward and S.S. Kresge brands.

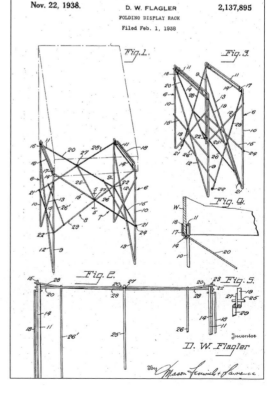

The folding display rack was invented by D.W. Flager in 1938. He transferred the rights to the Crosman Seed Company, which manufactured and used the racks in its business. The lightweight metal rack made it possible to display seed packets on a freestanding rack, rather than having to place the display on a table or counter. The packets could be viewed from a comfortable standing position.

The improved air gun was invented by William McLean in 1922. McLean had a difficult time finding financial backers for his air gun. The Crosman Brothers, who ran a seed business, agreed to finance the venture under the Crosman name. The air guns were made of hand-machined steel parts, which made the guns very expensive. The first shipments of air rifles were made in 1924.

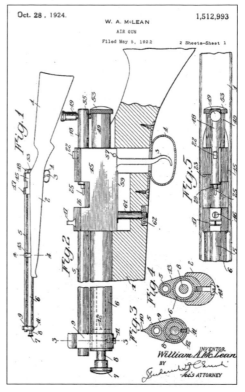

By 1953, Crosman Arms became a separate company and was no longer a division of the seed company. Crosman Arms bought the former Cobb Preserving Company buildings off Turk Hill Road near the canal after securing a major contract from Sears & Roebuck. Air guns and pellets were produced in this plant until 1985, when the last administration offices for the company were moved to East Bloomfield, New York.

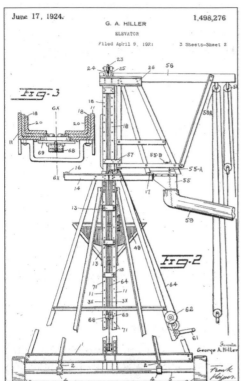

The Concrest development was a housing project of poured-concrete homes built by Kate Gleason in the early 1920s in East Rochester. A light moveable elevator was invented to pour the concrete two and three stories high into premade forms. The concrete elevator, built by the East Rochester Brass and Machine Company, was constructed of angle iron and could be telescoped from 19 to 47 feet. The light frame and wheels made it more mobile than the machinery on the market at the time.

Two Fairport brothers, Irving Kohler (left) and Milton Kohler (right), collaborated in the 1930s to patent a film-removing toothbrush. Even though the brothers were two years apart in age, they both graduated from Fairport High School in 1897. Irving Kohler graduated from the Medical College in Buffalo, New York, in 1911 and set up practice in Middleport, New York. Milton graduated from Buffalo Dental College in 1905 and returned to Fairport to practice dentistry.

Drs. Kohlers' Film Removing Tooth Brushes

FILM REMOVED OR MONEY REFUNDED

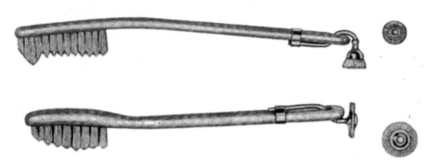
It took Dr. Milton Kohler and Dr. Irving Kohler 25 years to perfect their toothbrushes. The brushes, which attached to the back end of a standard toothbrush, were designed to wipe teeth clean and remove soft tartar and foreign particles. An article in the local *Fairport Herald* in the 1930s claimed that 500 brushes had been sold and that "no one has yet failed to see the real merit of this invention. On the other hand some patients are wondering whether the teeth are made too clean."

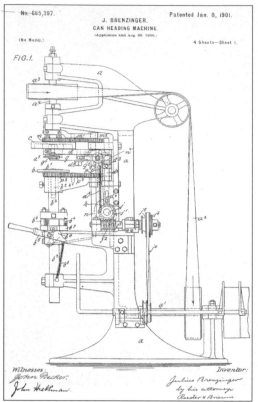

The solderless can was not invented in Fairport, but the owners of the Cobb Preserving Company perfected its use in the canning of food products. The Cobb Preserving Company made its own cans using the Max Ams Company machines, and by 1902, the operation was so big that the can-making division was split off and formed into the Sanitary Can Company. The newly formed company was given exclusive rights by Max Ams to use this machinery for the manufacturing of cans for sale.

The Sanitary Can Company moved to a building next to the railroad tracks on Parce Avenue. The building had been the Cox Shoe factory in the 1880s. It housed the Foster Pulley Works in 1902 and was sold to the Sanitary Can Company in 1904. George Cobb, general manager, spent $10,000 for improvements to the building. The men employed in the factory were capable of producing up to 50,000 cans per day. The company continued to produce cans for the next 92 years.

Daniel B. DeLand, grandson of the owner of DeLand Chemical Works, Levi J. DeLand, worked summers at the Cobb Preserving Company, soldering cans by hand. When the Sanitary Can Company was organized in 1904, Daniel became one of its first employees. In 1908, American Can acquired the Sanitary Can Company, and Daniel became plant superintendent at the age of 23.

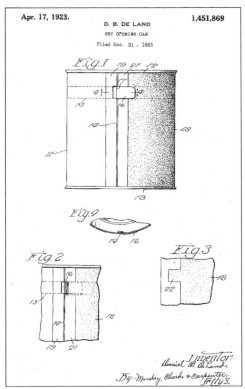

Drawing on his experience as a can maker, Daniel B. DeLand invented an improved key-opening can. Side seaming machines for these lithographed cans would sometimes solder the strip to the seam and prevent the key from engaging the tab. Daniel knew that solder would not stick to the lithography on the can, so by extending the printed surface under the tab, it would remain free of solder and unattached to the side seam.

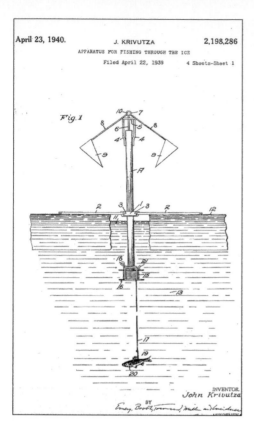

April 23, 1940. J. KRIVUTZA 2,198,286

APPARATUS FOR FISHING THROUGH THE ICE

Filed April 22, 1939 4 Sheets-Sheet 1

An avid fisherman, East Rochester resident John Krivitza invented an apparatus for fishing through the ice. John worked for many years as a machinist at Bausch & Lomb in Rochester and operated a saw-sharpening business out of his home on North Lincoln Road. His apparatus was a type of tip-up that had two flags that would pop up when a fish was caught on the line. This invention was manufactured by Arctic Winner.

In 1937, the sanitary hand pad was invented by Joseph Fiandach, who owned a barbershop at 111 North Main Street in Fairport. The pad was invented to eliminate the use of the familiar camel hair brush. This type of "neck duster" was used by barbers for a variety of purposes, from brushing off hair to applying talcum. Joseph Fiandach commented in his patent application that "the neck duster is thus a potential carrier of contagion and disease." The sanitary hand pad used a disposable tissue that could be removed after use for each individual customer.

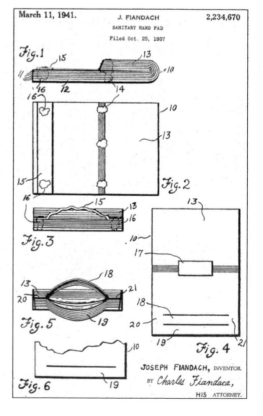

March 11, 1941. J. FIANDACH 2,234,670

SANITARY HAND PAD

Filed Oct. 25, 1937

Five

WATER, POWER, AND LIGHT

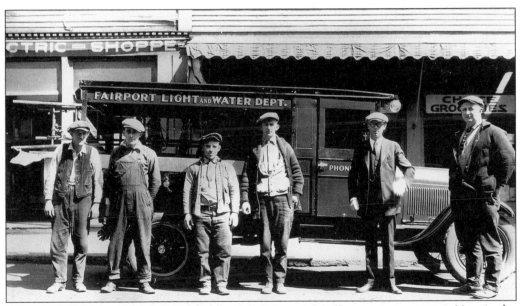

In Fairport, the era of lamplighters, kerosene lighting, and well water came to an end late in the 19th century with the creation of a board of light and a board of water. These soon merged into a single municipal commission. Employees pictured on West Avenue c. 1920 in front of Baylor's Electric Shoppe and J.D. Webb's Grocery Store are, from left to right, an unidentified man (possibly William Gardner or Charlie Struble), an unidentified man (possibly DeWitt Barnhardt or Happy Ostryk), Levi Wilkins, Jimmy Caler, an unidentified man (possibly Charles Sullivan or Kenneth Phillips), and George Caler.

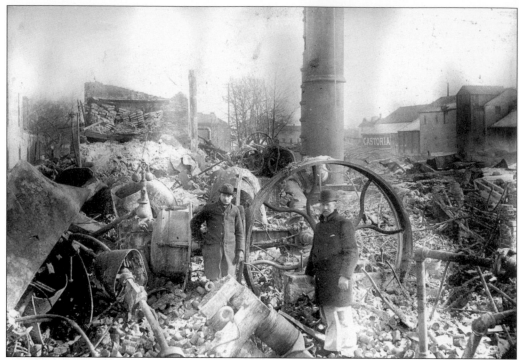

In 1893, five days after the disastrous DeLand Chemical Works fire, steps were taken to begin a waterworks in the village of Fairport. The lack of fire hydrants led to the complete destruction of the buildings of the largest employer in Fairport. Notice the thousands of destroyed cans of baking soda and saleratus on the ground.

The push for a waterworks was fueled by other issues as well. Retaining industry, such as Levi DeLand's successful baking powder business, was critical to the village's well-being. Health concerns also surfaced, as noted in the *Fairport Herald* in early March 1893: "Sewers are getting so foul that unless we have water with which to wash them out, they will breed a pestilence of typhoid and other fevers which will be as much worse than the former chills and ague as can be conceived of."

Fletcher Defendorf was elected one of six waterworks commissioners in a special vote at Shaw's Hall on March 21, 1893. He ran a stave and barrel factory in Fairport, which supplied many of the barrels used by the DeLand Chemical Company. Charles Peacock was elected chairman, and engineer Walter Randall was hired as an advisor to the new commission.

Annual Water Rates.

Established by the Board of Water Commissioners of the Village of Fairport, January 1, 1894.

BATHS.

Public, 1 tub	$10 00
" each additional tub	5 00
Hotel, 1 tub	8 00
" each additional tub	3 00
Boarding Houses, 1 tub	8 00
" " Each additional tub	3 00
Barber Shops, 1 tub	8 00
" " Each additional tub	3 00
Private Dwellings, 1 tub	3 00
" " Each additional tub	2 00
Offices and Sleeping Rooms, each tub	3 00
Single family in blocks, each tub	3 00
Single Dwellings occupied by more than one family having access to the same tub, each family	2 50

BAKERIES.

General Purposes, 1 faucet	6 00

By June, the voters had approved the creation of the municipal waterworks. Bonds totaling $43,000 were issued to finance the project, which would supply 600,000 to 800,000 gallons of water daily. Four wells were built on John Street and were connected to a standpipe on Summit Street. Filled in December, the standpipe soon froze and broke, as it was not insulated. At first only greenhouses had water meters. All other houses and establishments were billed by the number of baths, tubs, or faucets in the house. Hotels, boardinghouses, and barbershops were charged $8 for a tub and $3 for each additional tub.

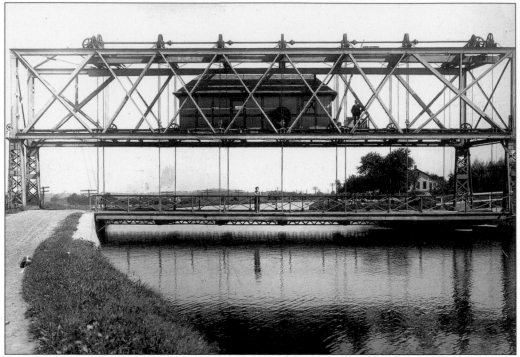

In 1903, the Fullamtown Bridge, a hydraulic lift bridge, was installed over the Erie Canal just west of the village of Fairport. It was connected to the village water mains and used 317 gallons of water for each lift. Some 1,251,977 gallons were used each season. At the time, the town of Perinton was responsible for the construction and maintenance of the bridge and was charged 10¢ to 15¢ per 1,000 gallons for use of the village water.

In 1922, warnings that drinking Fairport's well water could cause joint and kidney damage and hardening of the arteries prompted the municipal commission, under the leadership of town health officer Dr. George Price, to seek a new water supply. Water from Lake Ontario, several miles to the north, was suggested but was said to be too badly contaminated.

One hundred thirty acres of land was acquired near East Bloomfield in neighboring Ontario County for two reservoirs, with a watershed of four square miles. In 1932, increased consumption of water prompted breaking ground for another storage reservoir, pictured here on a small brook 1,000 feet from the original reservoir.

When completed, the new reservoir held 100 million gallons of water. The dam was earthen with a concrete core wall and was about 32 feet high and 500 feet long.

From the spillway on this second dam, a 12-inch pipe led to a filter plant two miles south of the village of Fairport, from which water was piped to the village distribution system. This arrangement lasted until 1988, when the village tapped into the Monroe County water supply.

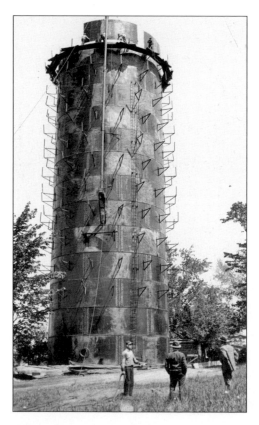

In 1932, a covered standpipe was erected on Moseley Road to handle the extra water from the newly created water supply from East Bloomfield. This structure, and one at the top of Summit Street, together held 1,050 gallons of water. The original standpipe on Summit Street, built in 1893, was not covered. Complaints by citizens who believed algae was growing on top of the water in the tank forced health officials on several occasions to climb to the top of the standpipe and check for debris and growth of bacteria.

Within two years, three water districts were created within the town of Perinton: Egypt, Bushnell's Basin, and Jefferson Avenue. Pipelines were built by work relief programs through the Civil Works Administration. The first outlying home to receive water was the home of Adrian Benedict, on the corner of Palmyra and Kreag Roads. The local paper reported that he drew water from a faucet in his basement at half past two on August 27, 1934.

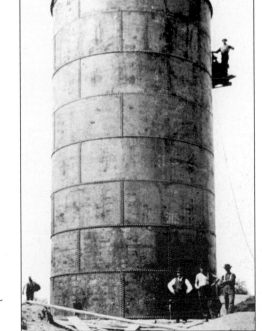

In the village of Despatch, water was supplied by springs before 1907. Later, lake water from the Rochester Lake Ontario Water Company was used until 1935. The following year, wells were dug near Fairport and Marsh Roads. This water tower was built c. 1905 on Filbert Street and Lincoln Road and was replaced in the mid-1930s by the tower that is still standing on Garfield and Maple Streets.

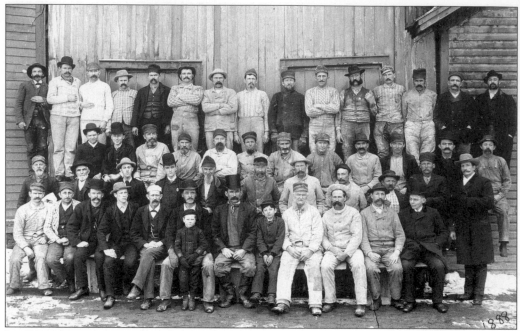

In the early 1880s, Daniel Culhane (front row, far left) became an employee of the DeLand Chemical Company, where he learned the trade of steam electrical engineer. In the late 1890s, he ran the first dynamo in western New York to produce power for incandescent lighting, which supplied power to the factory and lights to Levi DeLand's house on North Main Street. "It was a great day," said Culhane. "The whole town gathered to see electric illumination for the first time."

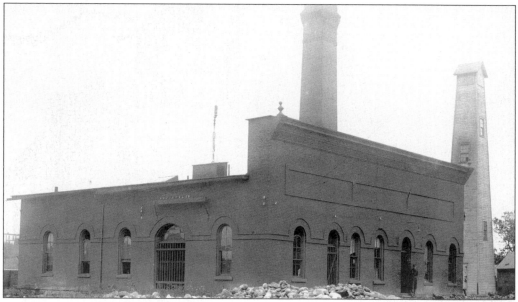

In 1901, the newly merged three-man municipal commission, operating in its new building on John Street, directed the installation of a steam generator to power 12 street lights and 40 village homes. The generator had a capacity of 150 kva (kilovat amperes), providing electric service from one hour before sunset to one hour after sunrise.

By 1905, service was supplied to 600 street lights and 194 customers. The following year, 24-hour service was available. Gas street lamps were replaced by electric lights, such as this one in front of the East Church Street home of Dr. James Cowles, an early village health officer.

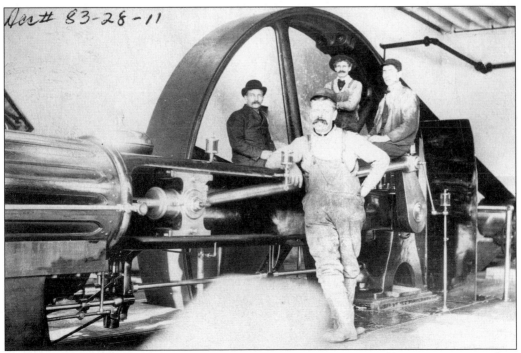

Industries such as the Sanitary Can Company depended heavily on village power to run their large generators. Power was needed to run the newly developed automated can-making machines.

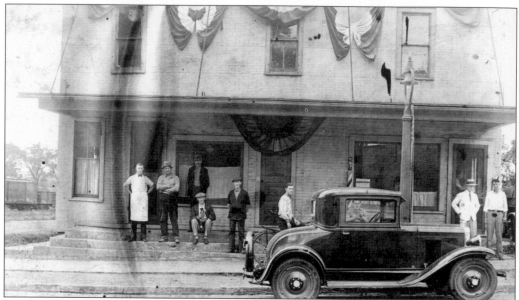

The benefits of creating a municipal commission were recognized early on. In a 1928 letter to the *Fairport Herald*, Fairport resident Sam Jacobson noted that his monthly bill was $5.77, while comparable use in Newark cost $6.96, and that a street light, like the one in front of what is now the Fairport Village Inn, cost $35 per month to power in Fairport and $86 in Newark.

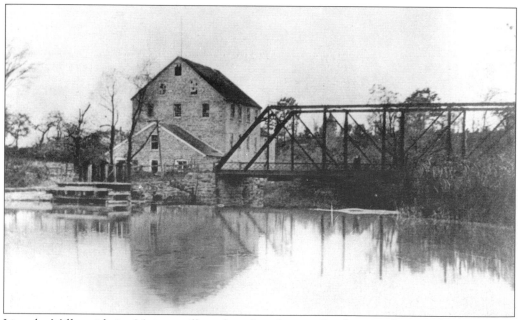

Lincoln Mills, with its 26-acre millpond on Irondequoit Creek at Linden Road, was a 19th-century flour mill. As the demand for electricity increased, this building and pond were bought in 1908 by the Despatch Power and Light Company and fitted with electric generators. In 1916, the millpond was destroyed when ice burst the dam. The site was abandoned by the owner (Rochester Gas and Electric), dynamited, and torn down in 1920.

Six
CHURCHES, SCHOOLS, AND ORGANIZATIONS

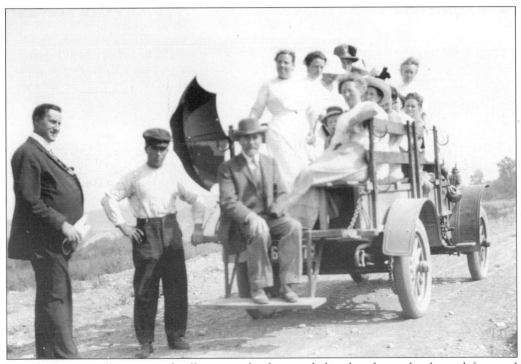

Social life in small towns and villages revolved around the churches, schools, and fraternal organizations. A popular church outing in 1912 was a trip to see the canal break at Bushnell's Basin. Here, Rev. Frank S. Kenyon, minister of the First Baptist Church, is about to hop onto a touring car going to view the damage. A collapse of a culvert under the canal during reconstruction caused a major break in the Great Embankment on September 3, 1912.

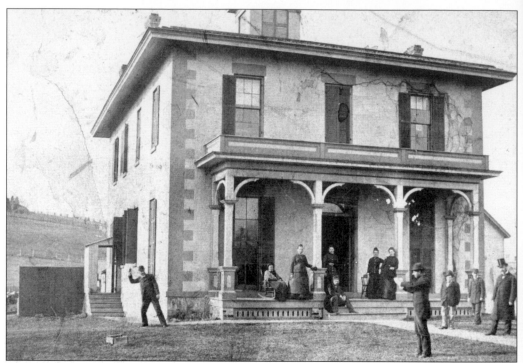

This versatile building at 38 East Church Street served many purposes. From 1855 to 1870, it was a school for District No. 9 in Fairport. It was a boardinghouse and later a residence. In 1951, it became the Fairport Gospel Center. The center was both a church and the residence of Rev. Albert D'Annunzio and his family until a fire in 1970 destroyed the building beyond repair.

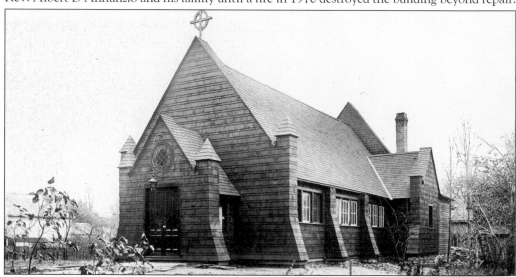

In 1908, faced with declining participation, Rev. William Davis revitalized his congregation by tearing down the old church and building the new St. Luke's Episcopal Church in its place. Davis worked alongside the carpenters as they reused as much of the old building materials as they could in the new construction. The material cost of the building was $800; wages were paid to the workers each week from money donated by parishioners. The congregation left the building for a larger church in 1968.

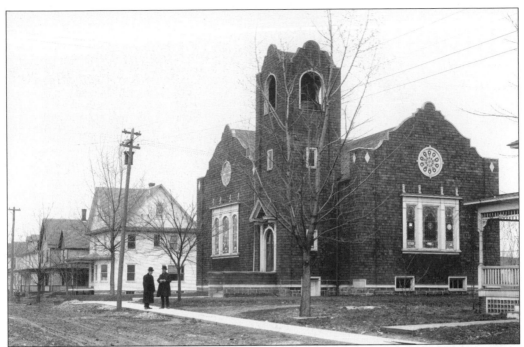

Built in August 1904, the First Baptist Church, on West Elm Street in Despatch, was designed by Frank Hamilton, with the drawing executed by architect J. Mills Pratt. The church had nine stained-glass windows, an auditorium with baptistery, and a Sunday school room. The outside of the building was extensively remodeled in 1925, with modifications to the roof and replacement of the shingles with white stucco.

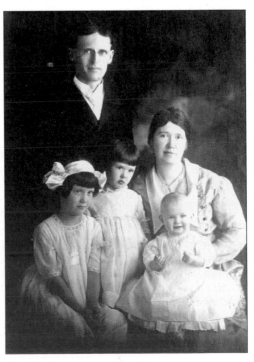

Dr. David Crockett Graham married Fairport native Alicia Morey, daughter of store owner Joseph Morey and his wife, Jennie. The First Baptist Church of Fairport voted in 1911 to support the Grahams on a mission to China, the first missionaries sent from this church. The Grahams worked in Szechwan and Chengtu, China, for 37 years and witnessed the bombing of Chengtu by the Japanese in 1941. David and Alicia had six children. The three children pictured here are, from left to right, Margaret, Ruth, and Harriet Jane.

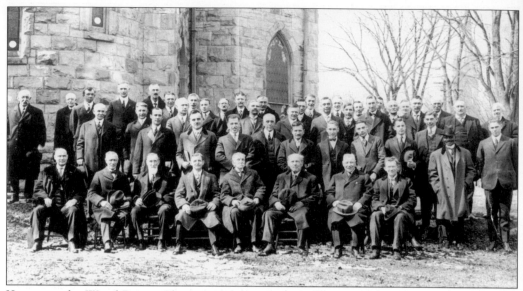

Known as the Wood Baraca Class, named after Rev. William R. Wood, this group of men met at the Raymond Baptist Church in 1919 "to promote a systematic study of the Bible, to aid in the organized work of the church and to cultivate social fellowship among its members." (*One Hundred Anniversary Raymond Baptist Church 1840–1940.*) Rev. H.R. Saunders (third row, sixth from the left) was the teacher and continued in that position for 16 years. The group's annual Turkey Banquet raised funds to maintain the church building and grounds.

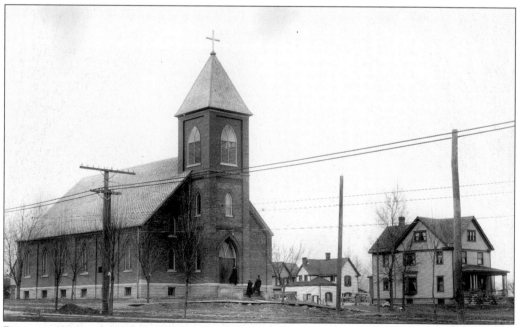

Between 1903 and 1905, the Roman Catholic population in Despatch had increased from a few Catholics to 40 families. The need for a church was met in 1906 with the construction of St. Jerome's on Commercial Street. The people of the parish met the Rochester train at the Despatch station and escorted Bishop Bernard J. McQuaid and many visiting priests to the church at Commercial and Garfield Streets to lay the cornerstone.

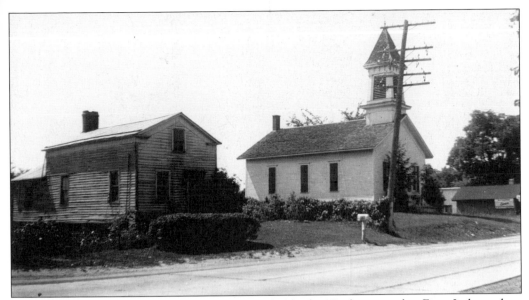

Through the efforts of Lyman Wilmarth and Charles Dickensen, the First Independent Congregational Church was built in Bushnell's Basin in 1831. The building was used for many years as a mission for several denominations. Among the lecturers that visited this church was women's rights activist Susan B. Anthony. The building has changed hands several times. It was renovated into a jewelry store in the 1980s and is currently vacant.

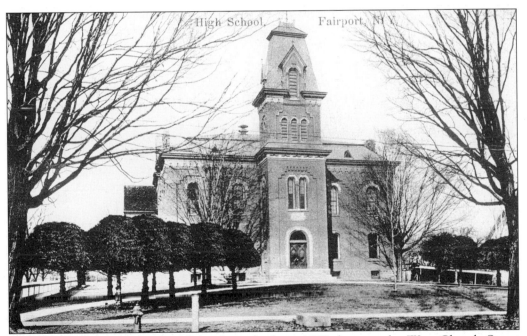

The Fairport Union School and Academy, built in 1872, became the West Church Street School in 1924, when the West Avenue School opened. The building served as a grade school until 1955. In 1939, the distinctive cupola and the golden feather weathervane were removed due to extensive weather damage.

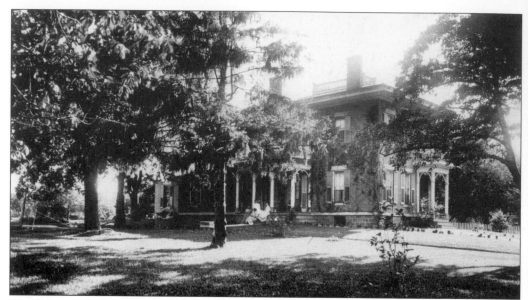

The Schummers home and property, at 71 West Avenue, was bought by the school trustees in 1916, and the land was added to school property that abutted it from the south. The house was remodeled into additional grammar school classrooms the following year. In 1923, the building was razed to accommodate the building of the new high school.

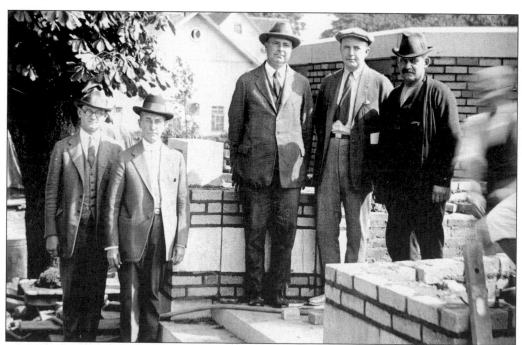

The laying of the cornerstone of the new West Avenue High School was attended by, from left to right, Claude Hardy, superintendent of schools; Will O. Greene, *Monroe County Mail* newspaper editor; Yale Parce, school board president; Raymond Dudley, school board member; and DeWitt Barnhardt, member of the board of education.

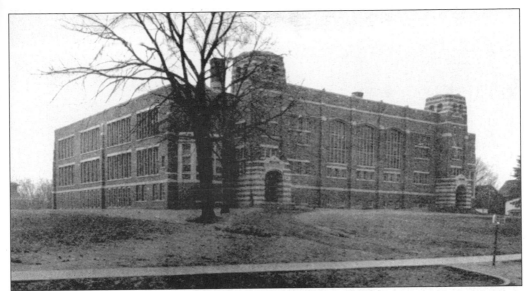

The two-story West Avenue School was opened in 1924 as a junior and senior high school. It was designed by O.W. Harwood and B. Dryer and was built for $340,000. Today the building is known as Packet's Glen and provides senior apartments in some of the rooms occupied by former students.

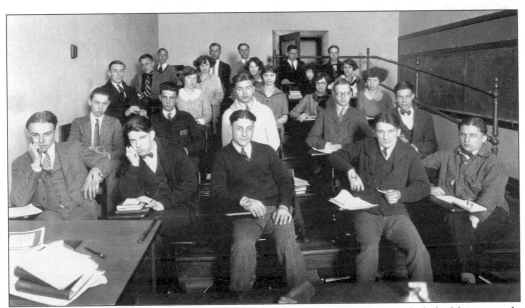

The building provided new rooms designed for modern learning. These included a library, study halls, an art room, an accounting room, a lunch room, and a manual training room. This is one of two science labs; one was used for biology, and the other was for chemistry and physics.

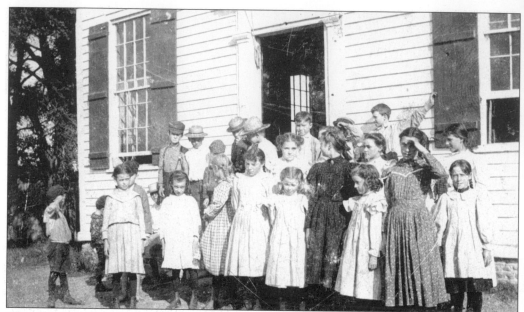

The children in District No. 4 in the early part of the 20th century were mostly from farm families near the hamlet of Egypt. Because of the sandy soil, many of the families raised hundreds of bushels of potatoes. These children had the last week of October off from school for what was called a potato-digging vacation.

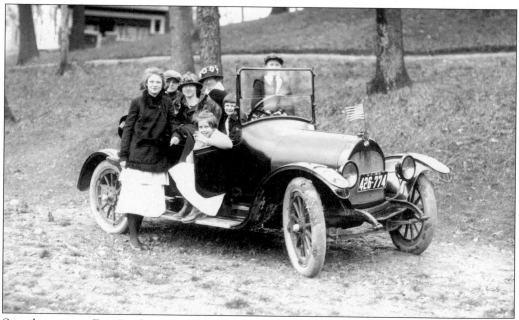

Seen here in an East Rochester park with some of her students, May Chesbro (fourth from the left) taught physical training in the rural schools in the area in 1918. She used her Oakland roadster to visit the remote schools. Mable Chesbro, May's sister (third from the left), was a music teacher in the East Rochester school system.

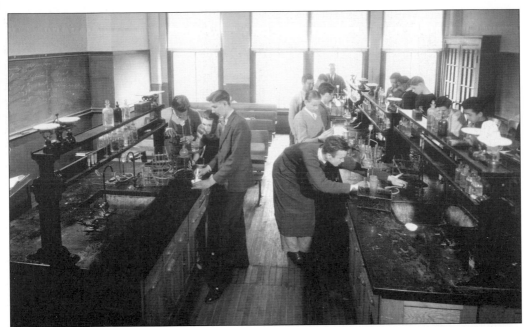

The East Rochester High School was built in 1911 on East Avenue in the village. From that time until the 1940s, entering high school students from neighboring districts in Perinton could choose to go to this high school or to Fairport High School on Church Street and, later, West Avenue. A new building, built as a Works Progress Administration project in 1937, was connected to the old high school by an underground tunnel. This physics class was held in the old building c. 1936. The teacher, Mr. Skinner, is standing in front of the windows.

Known as the Elite Club, this group of Fairport men met over the F.F. Schummers Hardware Store c. 1907. They are, from top to bottom, Ed Brown, George Fellows, D.B. Howard, Sabin Schummers, and George Holman.

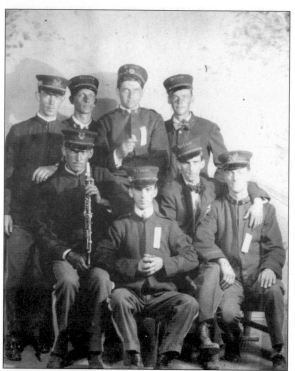

Organized in 1881, the DeLand Band would often accompany the Fairport Fire Department on parade. The name of the band changed over the years from the L.J. DeLand Band to the DeLand Cornet Band to the DeLand Military Band. Even after their sponsor, the DeLand Chemical Company, went out of business, the band continued to march and play concerts for local events well into the 20th century.

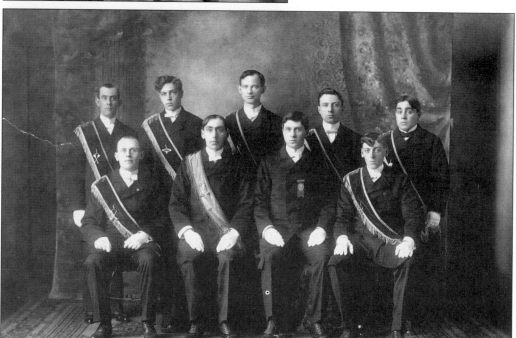

The Order of Redmen began as a social group after the Revolutionary War. Later, the Improved Order of Redmen began to provide financial aid for sick and distressed members and their families. The Ke-Ne-Hoot Tribe No. 366 was established in Fairport in 1897 and had an active membership into the 1930s. The group had a secret telegraph code that was used to relay specific information about health or burial arrangements to other tribe members.

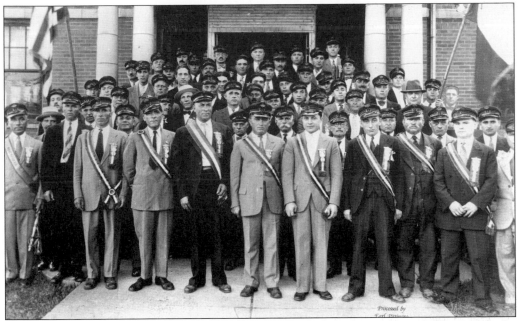

Men of Fairport's Italian community formed the San Sebastian Society on February 23, 1915, in the Fiandach Building on North Main Street. These men formed the society as a social group and mutual aid society. The group, outfitted with its own uniforms, usually made up the largest contingent in any local parade. The society was active until the 1960s.

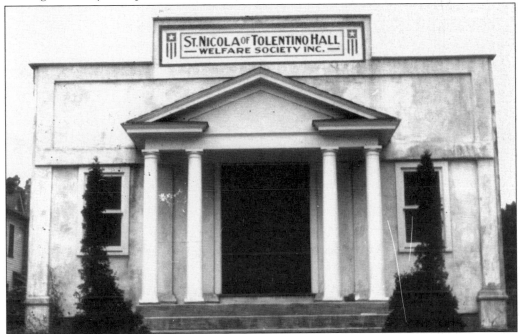

The East Rochester equivalent of the San Sebastian Society is the St. Nicola of Tolentino Hall Welfare Society. The society was founded in 1926 for the general welfare of the Italian community in the village. Early founders of the society were masons, who donated their time to build the meeting hall at 206 Madison Street on the Luigi Mauro property.

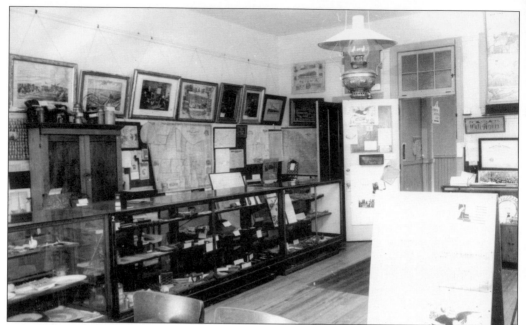

Founded in 1935, the Perinton Historical Society began accumulating artifacts in the 1940s. The artifacts were stored in a small loft in the Fairport Public Library until 1964, when the town of Perinton offered a room in the former Northside School on East Avenue for the display of the collection. The collection remained here for 15 years, until the society moved to its present location at 18 Perrin Street in the former library building.

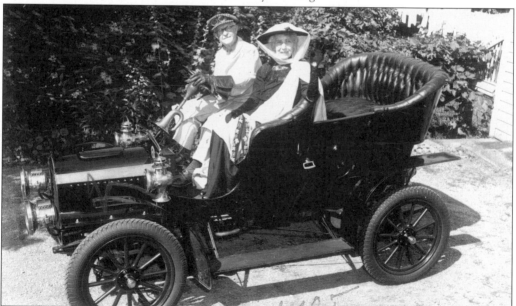

In October 1920, the Fairport Auto Club started a vigorous campaign to recruit members from the estimated 700 to 800 automobile owners in Fairport. Albert B. Hupp, shown here with his wife, Alice, in their 1905 Ford, was one of the founding members. In 1920, he started Hupp Motors at 92 South Main Street in Fairport. He sold Fords, Lincolns, Zephyrs, and used cars until his retirement in 1936.

Seven
FIRE DEPARTMENTS

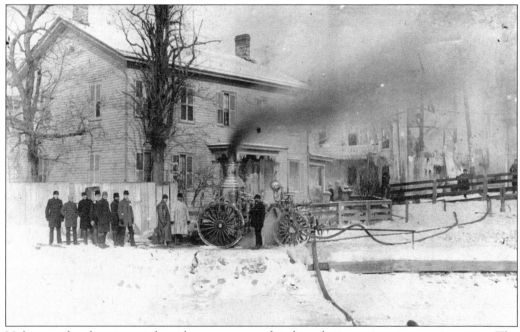

Volunteer fire departments have been a source of pride and security in many communities. The Fairport Fire Department was founded in 1877, primarily to protect the DeLand Chemical Works. There were no fire hydrants in the village, so pumper trucks pulled water from the Erie Canal and nearby creeks. This pumper truck is on the scene of the DeLand Chemical fire of February 4, 1893. The firemen, in front of the Pritchard Hotel, had to cut a hole in the ice and pump water to the blazing factory across the street.

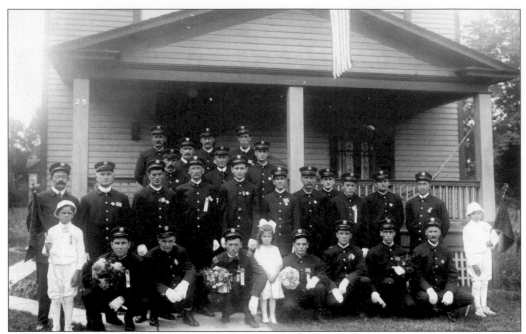

The Fairport Fire Department was formed from three companies: the DeLand Hose Company (1877), the Hook and Ladder Company (1881), and the Fairport Protective Association (1888). Shown here is the DeLand Hose Company in 1919 as they gather before a parade. Flowers are carried in remembrance of deceased members. The children carried flags and banners in the parade.

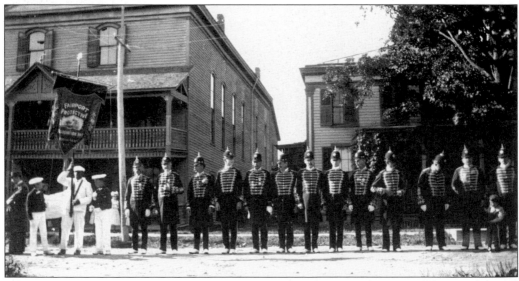

The Fairport Protective Association was organized to restrain crowds at fires and to remove and protect property from the buildings after the fire. These men also had chemicals at their disposal to use in extinguishing fires. The Protectives are lined up on West Avenue with Shaw's Hall in the back to the left. This picture was taken before the balcony was removed and the familiar brick facade added.

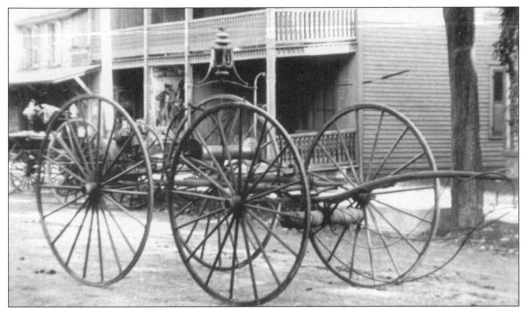

The first wheeled equipment was a hose cart, which carried 650 feet of hose. The department also owned a ladder truck (not shown), which held six ladders, hooks, pike poles, axes, buckets, ropes, and two hand extinguishers. The fire department did not keep a team of horses at the fire hall. The first firemen to arrive at the station were responsible for pulling the carts to the fire.

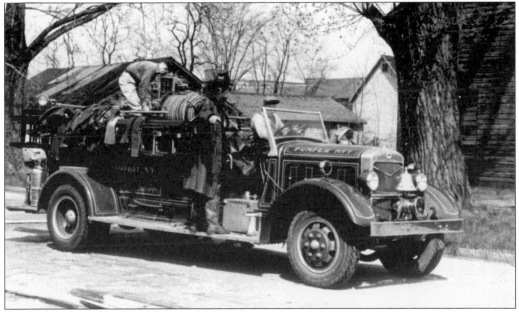

Fire carts continued to be pulled by firemen until 1917, when the Fairport Village Board purchased an attachment for the rear axle of a car that hooked up to the cart. This arrangement lasted just two years before the arrival of motorized equipment. This hook and ladder was one of four trucks bought by the village of Fairport, which earned it a Class A fire insurance rating in 1924.

SPECIAL ORDERS.

The following order the Hose Company will observe: In case fire occurs on the North Side, or in Districts No. 3 and 4, the South Side Hose Cart will not go to the fire. In case fire occurs south of the canal or in District No. 1 and 2, the North Side Hose Cart will not go. The Central Hose Cart will go to all fires, but in case of large conflagration in the central business part of the village, the foreman will see that all hose carts go.

Order to Protective Chemical Company: You will at once, on arriving at the fire, stretch your rope in front of burning building, to keep the crowd back so the firemen will not be hindered in their work.

The Janitor will see that the rooms in cold weather are well heated for these meetings, and everything kept in good shape. Any of the companies having special meetings will notify the Janitor of the same.

DIAGRAM OF FIRE DISTRICT.

3		4
ERIE	MAIN STREET.	CANAL
1		2

Fairport Fire Department.

List of Officers, Date of Meetings, Signals,

SPECIAL ORDERS, ETC.

Rooms in Chadwick Block, West Avenue,

FAIRPORT, N. Y.

In the early days of the fire department, the alarm was a steam fire whistle located at the DeLand Chemical Works. The village was divided into four districts—one and two on the south side of the canal and three and four on the north side. After one long blast of the whistle called a general alarm, there would be a series of short blasts indicating in which district the fire was raging. One blast indicated district one, two blasts district two, and so on.

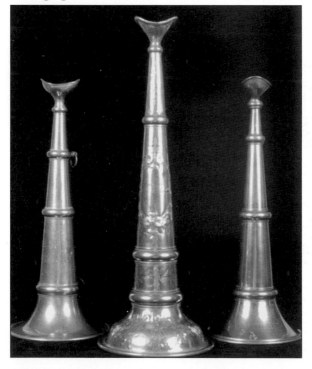

Before the use of radios, commands at the fire scene were given by the fire chief through the use of a speaking trumpet. The trumpet had other uses as well. It signified the officer in charge at the fire scene. It carried flowers in remembrance of deceased members. At banquets, the narrow end could be plugged, and the trumpet could be used for drinking. Finally, an engraved trumpet was sometimes presented to a retiring chief as a gift from the fire department.

84

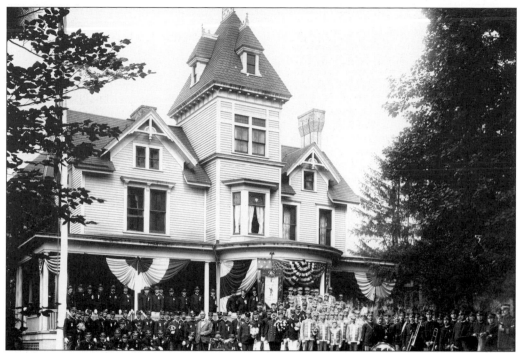

The Northern Central New York Volunteer Fireman's Association held conventions in Fairport in 1899, 1908, and 1916. The 13th annual convention, in 1908, was held in conjunction with Fairport's Old Home Week celebration. Here, the firemen are on the front porch of the Parce house, at 137 North Main Street just a block from the fairgrounds on the DeLand property.

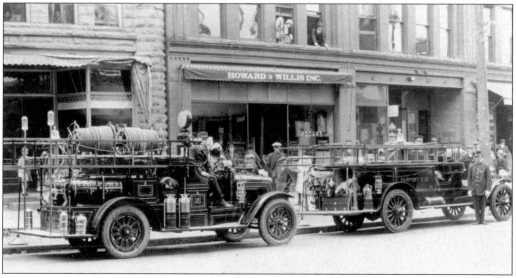

The pumper (left) could deliver 350 gallons of water per minute, and the chemical truck (right) had three tanks. The new fire trucks, seen here *c.* 1920, are in front of the Bown and Adams Blocks on South Main Street. The little boy standing between the trucks is Clair "Cal" Stewart. Years later, he was the chief of the Fairport Fire Department for nine years and subsequently became Monroe County fire coordinator.

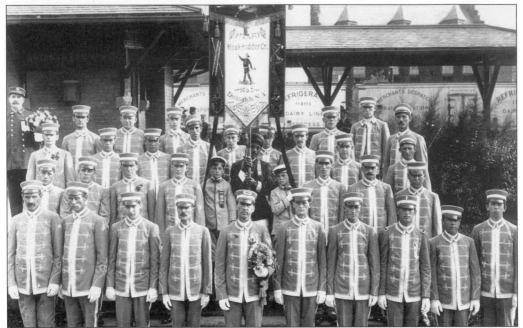

The present East Rochester Fire Department was founded in 1898 as the Despatch Fire Department and has always protected a portion of Perinton as well as all of East Rochester. The Ontario Hook and Ladder Company was one of three companies within the department. The men seen here are in front of the train station on East Commercial Street. Refrigerator cars built at the Merchants Despatch Transportation Company are shown behind the waiting platform.

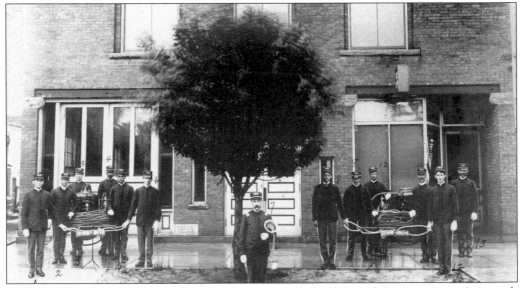

The second company in the department was the Despatch Chemical Company, seen here with their chemical carts. The building to the rear housed the fire department on the left, the police station on the right, and the Despatch Village Hall upstairs. The second floor was also used as a community hall. With the passage of time, the fire department grew to fill the first floor of the building.

One of the worst fires in East Rochester's history occurred in 1914, when the Eyer Block burned. Here, hose wagons stand ready to be reloaded and taken back to the fire hall. The building suffered almost total destruction, but it was rebuilt and still stands in East Rochester today. Although many fire departments eventually replaced manpower with horses for the transport of wheeled equipment, there is no evidence that East Rochester ever used horses.

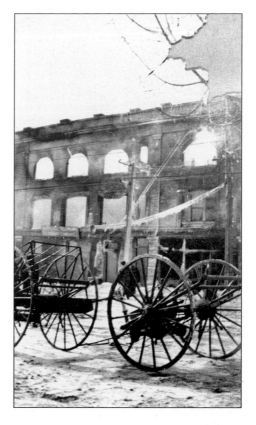

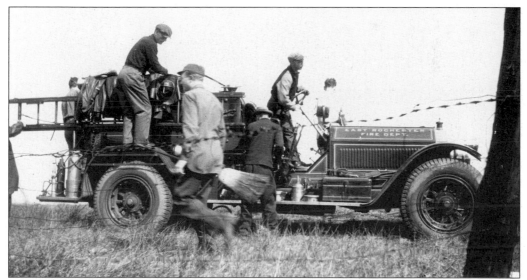

Skip Burlingame is seen here driving a 1925 American La France pumper while fighting a grass fire in April 1936. The truck is being driven slowly along the periphery of the fire, while firemen use hoses to wet down the burning grass and others use brooms to sweep out the fire. Three generations of Burlingames (Skip, his father, Willis, and his son Jim) served the East Rochester Fire Department for more than 75 years.

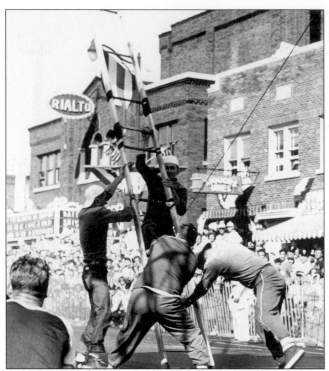

Training is a vital operation in every fire department. It develops skill, knowledge, and speed. The result of training is demonstrated at competitions held at fire conventions. In this photograph, East Rochester firemen are competing at the New York State Firemen's Convention, held in East Rochester during August 1952. The ladder race is being run in front of the Rialto movie theater on Main Street.

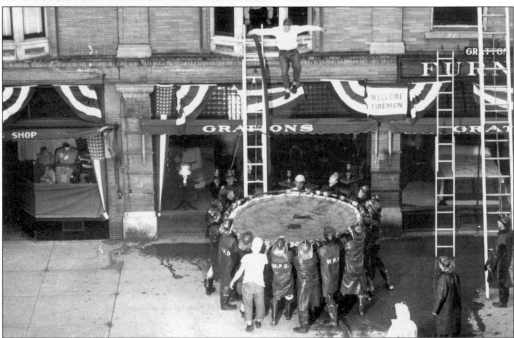

In the 1950s, life nets were still used to save people jumping out of burning buildings. The practice was rarely successful and is not often used today. Hydraulic ladder trucks, which can reach upward to 10 floors, are much more effective in saving lives and avoiding injuries. This man is jumping out of window from the Eyer Building in a demonstration at the New York State Firemen's Convention in 1952.

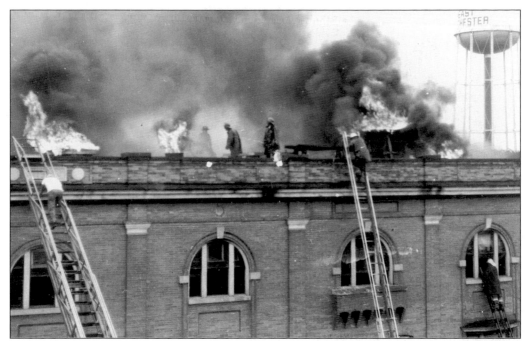

A demonstration fire gone wrong occurred at the fire convention on top of the Eyer Building, 38 years after it had burned to the ground from a real fire. Flat pans of oil were placed on the roof and ignited to simulate a roof fire. The oil started to boil and spill out of the pans onto the roof, causing a real fire; it was quickly put out by the firemen.

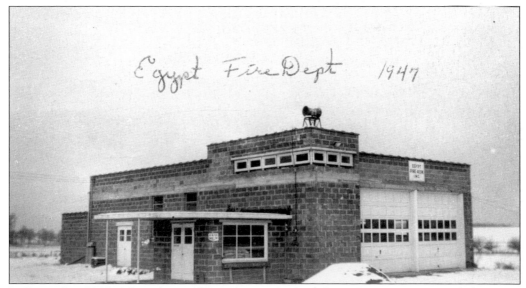

In December 1945, 26 residents of Egypt, an area in southeast Perinton, organized the Egypt Volunteer Fire Department. This was the second rural fire department established in the town. Previous to 1940, all fires in the town of Perinton were handled by fire departments in the surrounding villages of Pittsford, East Rochester, and Fairport. The fire departments were sometimes several miles from the farthest farmhouse or barn in the town.

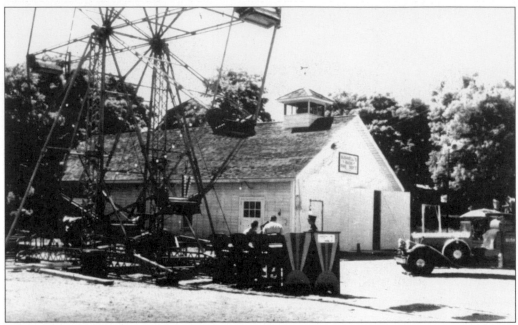

The original fire hall for the Bushnell's Basin Fire Department was built from 1941 to 1942. In the early days, most funds for volunteer fire companies came from donations from residents and businesses served. The Ferris wheel on the grounds was part of a carnival held to raise money for the department, an event still found today in other fire departments to supplement local taxes.

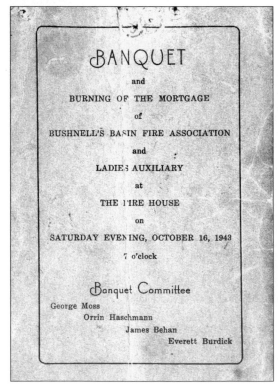

BANQUET

and

BURNING OF THE MORTGAGE

of

BUSHNELL'S BASIN FIRE ASSOCIATION

and

LADIES AUXILIARY

at

THE FIRE HOUSE

on

SATURDAY EVENING, OCTOBER 16, 1943

7 o'clock

Banquet Committee

George Moss
Orrin Haschmann
James Behan
Everett Burdick

Two years after ground was broken for the new fire hall, the mortgage was paid off, and a banquet was held to celebrate. A brief history inside the program said that the fire department had been organized in 1940, the lot purchased in 1941, and the building raised on December 7, 1941, Pearl Harbor Day. The day the banquet was held, there were nine volunteer firemen from this department serving in the armed forces.

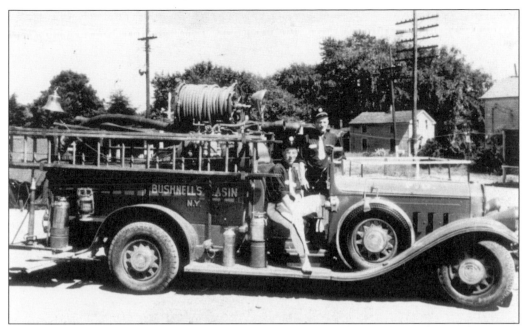

Vincent Peglow (left) and Chief George Moss (right) are posed on one of the first trucks acquired by the Bushnell's Basin Fire Department. This truck was a combination of the original Brockway body, the chassis of a used 1933 Pierce-Arrow limousine, and the equipment from yet another truck.

In 1979, the only fire hall in New York State manned by two separate fire departments was dedicated at the corner of Moseley and Garnsey Roads, located at the intersection of two fire districts, Bushnell's Basin and Egypt. Each company operates one fire pumper out of this building. The fire hall was created because of the increased population growth in this section of the town of Perinton.

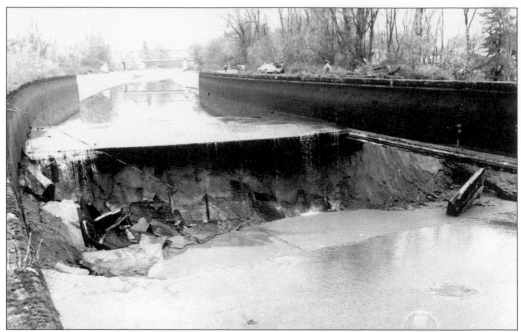

Fire departments do more than fight fires. On October 29, 1974, a tunnel being constructed under the Barge Canal collapsed, creating a hole in the bottom of the canal in Bushnell's Basin. Water roared through the adjoining neighborhood, destroying two homes and damaging 39 others. Firemen kept the fire station open for eight days to respond to the many requests to pump out basements, clean walls and floors, and look for personal effects.

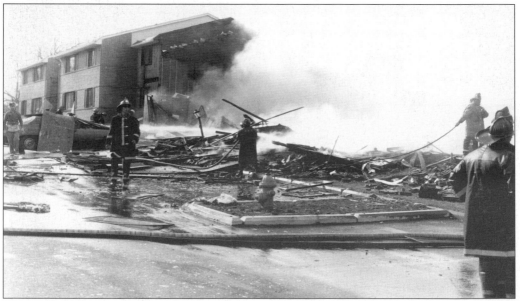

Protective clothing for firemen has improved over the years. The firemen seen here fighting a fire on April 17, 1973, are well protected with hard helmets, heavy coats, bunker pants, and boots. Modern materials offer greater protection and less weight than those of earlier years. This natural gas explosion leveled a two-story apartment building at Perinton Manor Apartments and left three other buildings uninhabitable.

Eight

SPORTS

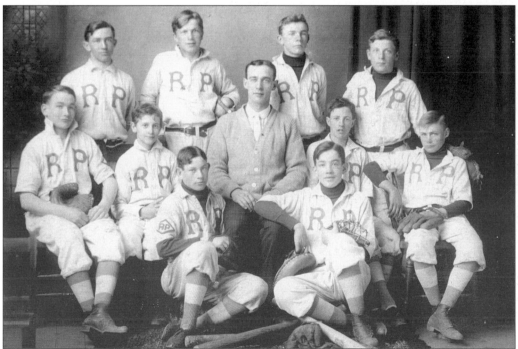

Sports, especially baseball, were popular throughout much of the 20th century. Baseball was considered America's national pastime, and in 1912, Perinton supported four amateur baseball teams. Amy Rush Smith (middle row, third from the left) held tryouts and organized teams known as Rush's Pets. His team became known as the Can Makers in 1913 because most of its members were employed by the Sanitary Can Company.

Fairport baseball fans Dr. Irving Bramer, Dr. James Welch, Rudy Maurhoffer, and Ned Wright (from Albany) took the train to Boston in 1915 to see the Philadelphia Phillies play the Boston Red Sox in the third game of the World Series. Welch would see his second World Series game 50 years later in Minnesota, as the Twins took on the Los Angeles Dodgers in game two.

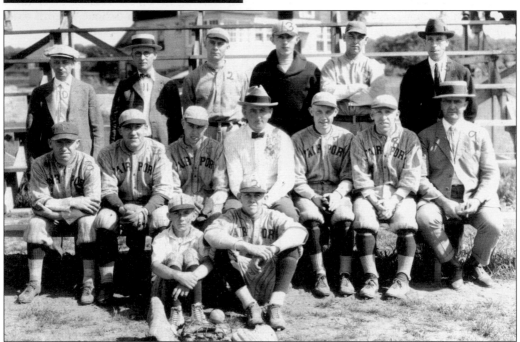

The Fairport team won the 1923 Democrat and Chronicle League Championship under manager Floyd Terpening (middle row, fourth from the left). Terpening also led a Fairport team to a championship in 1908 and brought home the Spalding Trophy, given to the best team in the league by the Democrat and Chronicle.

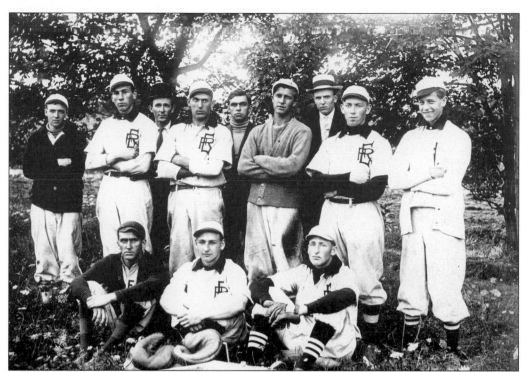

Talented rookies from the high school sports teams were signed up for local amateur town teams. James Welch (front row, far right) played on the Fairport High School baseball team that won the Monroe and Ontario Counties Interscholastic League championship in 1907. James is seen here with the East Rochester team *c.* 1910.

Edward R. Brown was elected secretary of the Fairport Athletic Association in 1905. The fields where the teams played were at Central Park behind the old Fairport Union School, with an entrance on Perrin Street. The teams played on Saturday afternoons. A season ticket for 15 games was $2.

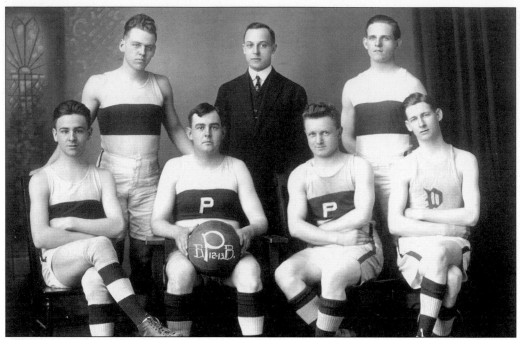

The Perintons were a local town basketball team in 1913. The team played 19 games that season, winning 12 of them against such rivals as the Saturday Evening Posts, the Pontiacs, and the Brockport Independents.

Joseph Cummings (fourth row, fourth from the left) started his coaching career at Fairport High School in 1936. A graduate of Cortland Normal School, Cummings was one of 27 physical education students from around the country chosen to attend the Olympics in Berlin, Germany, as a representative of the International Sports Education Congress. As a college undergraduate, he had letters in football, basketball, and track.

The East Rochester High School
teams were first referred to as the
Bombers by local newspaperman
Louis "Cabby" Providence in an
article about Dick Baroody's 1949
basketball team. Providence
associated the scrappy hometown
team with the prizefighting career of
Joe Louis, also known as "the Brown
Bomber." Prior to 1949, the East
Rochester teams were known as the
Brown and Whites and the Piano
Towners, named after the Foster-
Armstrong Piano Works, which had a
factory on Commercial Street.

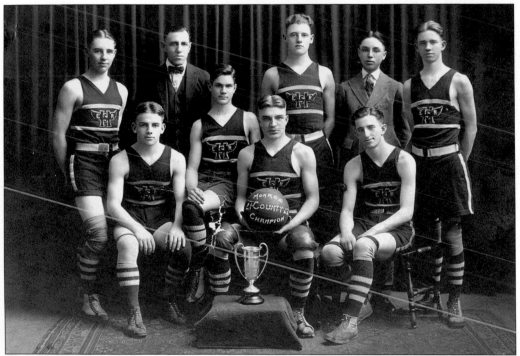

The East Rochester High School basketball team won the 1921–1922 Monroe County
Championship. Edward "Pop" Seward (back row, second from the left) coached this team to
East Rochester's first basketball title.

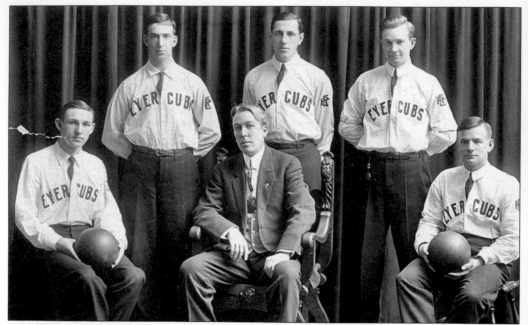

The Eyer Cubs were a local bowling team in East Rochester c. 1912. They bowled on the alleys located in the basement of the Eyer Block, on Main Street. The alleys were built under the sidewalk. Because of its location over the lanes, the sidewalk was always free of ice and snow in the winter.

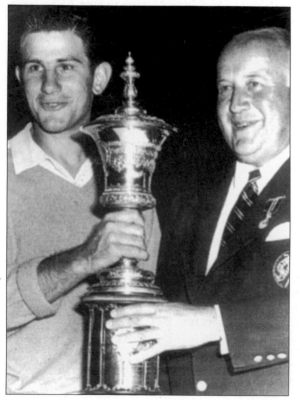

One of the more famous athletes from East Rochester is Sam Urzetta, winner of the 1950 National Amateur Golf Title. He became known locally as "the king of amateur golfers." Urzetta played favored Frank Stranahan, defeating him on the 39th hole. Shown here accepting the trophy from Professional Golfers' Association president James Standish, Urzetta later played on the tour and was head pro at the Country Club of Rochester for 37 years.

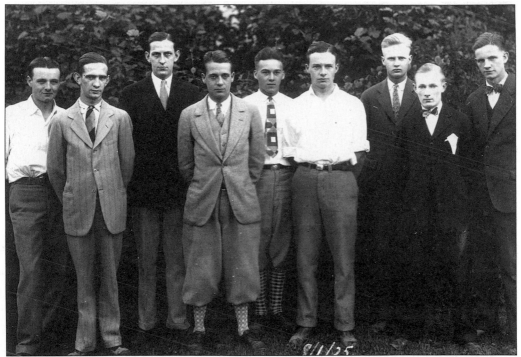

Known as the father of modern golf course architecture, Robert Trent Jones (fourth from the left) built approximately 310 courses and redesigned 150 others. Moving to East Rochester in 1909 from Ince, England, at the age of three, Jones designed golf courses in 45 states from 1930 to 1990. He was given the middle name of Trent (after a river in England) by a group of high school classmates.

The Midvale Golf and Country Club was the first golf course designed by Robert Trent Jones in 1930. Golf was becoming increasingly popular in the 1920s and 1930s, with 12 courses in the Rochester area at the time. The 18-hole Midvale Course, located in the northern part of the town of Perinton, was popular in the suburbs because of its proximity to the villages of East Rochester, Fairport, Pittsford, and Penfield.

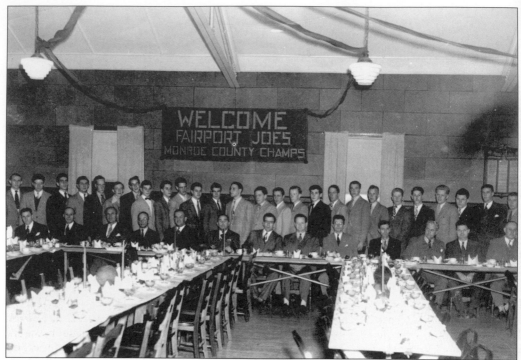

Fairport High School teams were known by various nicknames, including the Red and Blue and the Big Red. The 1952 Fairport High School yearbook referred to its sports teams for the first time as the Red Raiders. The football teams were affectionately known as the Fairport Joes after Joe Cummings, who was the coach from 1936 to 1941 and from 1946 to 1961. Football teams under Cummings won county championships or were co-champions for seven seasons.

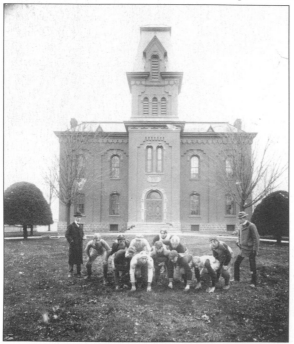

Leather helmets and cotton-filled shoulder pads were the standard equipment for football teams in the early 20th century. These players are on the lawn of the Fairport High School, also known as the Classical Union School and the Fairport Union School and Academy, which was located at 38 West Church Street. The school teams played on their home fields in back of this school.

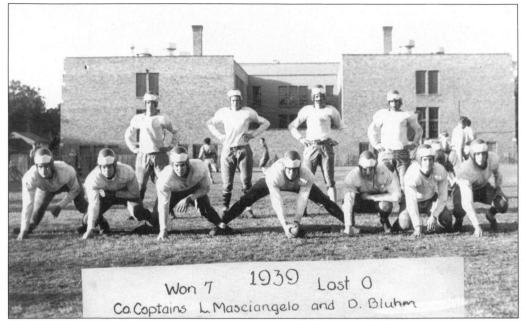

Won 7 1939 Lost 0

Co.Captains L. Masciangelo and D. Bluhm

In 1939, Perinton town supervisor Ken Courtney started the Little Brown Jug game between the high school football teams of the villages of East Rochester and Fairport. The winners of the annual game would have the privilege of keeping the jug in their school until the next contest. The 1939 Fairport football team won a victory over the East Rochester team 24-0 in the first Little Brown Jug contest.

East Rochester Lions Club president August Corea gave Fairport Lions Club president Hawk DiRisio a ride through the Fairport village in a wheelbarrow in 1950 after Fairport beat East Rochester in the Little Brown Jug contest. This tradition was carried on in following years, with the losing mayor pushing the winning mayor down Main Street. The Little Brown Jug competition ended in 1989, with Fairport having won the jug 22 times, East Rochester having won 26 times, and 1 tie.

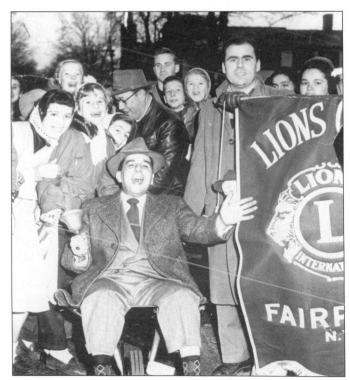

The 1948 football team sported new uniforms with stripes on the sleeves. The small, intimate sports field behind the West Avenue High School was close to neighborhood backyards, where homeowners could get a free peek at the teams. The back of the public library can be seen on the right.

These Fairport cheerleaders are preparing for a football game against the Webster High School team in October 1947. They are, from left to right, Justine Dunn, Greg Barnes, Margaret Marvin, Jerry Williams, Mary Scida, and Jerie Mead.

Nine
DURING WARTIME

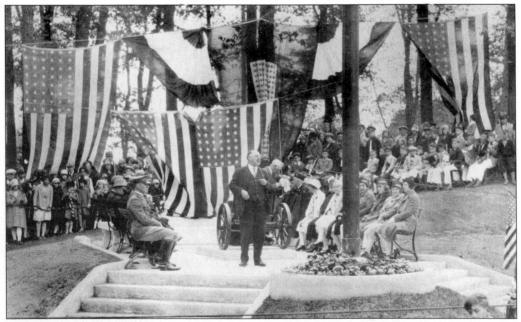

War arouses many emotions in communities—fear, pride, hope, sadness, patriotism—as the young leave for war and the town waits for news. After a war, memorializing those who have died becomes an important goal. One of four war memorials for 20th-century soldiers in the villages of East Rochester and Fairport, this World War I cannon is being dedicated in 1931 at Edmund Lyon Park in the village of East Rochester.

In July 1929, Robert Douglas, local manufacturer and inventor of Certo, left 500 shares of stock from his estate to build a new public library for Fairport. Four months later, the stock value fell on Black Friday, when the New York Stock Exchange crashed. By 1931, the gift had been reduced to 70 percent of its original value. The Perinton Patriotic League's executive committee pledged the war chest collected during World War I to make up the difference and helped make the building of a new library possible. The library, a Works Progress Administration project, was finished in 1937 and was dedicated to the men and women from Perinton who served in World War I. This photograph was taken by Josef Schiff.

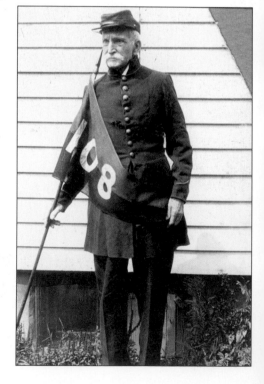

Chester Hutchinson, one of the last Civil War veterans, marched in local parades into the 1930s. He enlisted in the 108th New York Volunteers on August 4, 1862. The unit traveled in cattle cars to New York City and then to Washington, D.C., where Hutchinson slept his first night on the east steps of the White House. He was wounded during his first battle at Antietam and again at the Battle of the Wilderness. Mustered out on June 1, 1865, Hutchinson returned to Fairport, where he worked at a lumber company and was active in community organizations until his death on April 19, 1932, at the age of 90.

A descendent of an early Perinton family, William Freeman Fullam was a midshipman who served in the navy during the Spanish-American War. He was promoted to rear admiral in 1914 and was assigned to duty as commander of the reserve force for the Pacific Fleet from 1915 to 1917. Fullam retired in October 1919 after 46 years of continuous service.

During World War I, Charlotte Clapp worked on the war library drive. In 1921, she was hired as Perinton's first town historian and was given the responsibility of writing the world war history of Perinton, which was incorporated into the book *Monroe County History of the War*. She was appointed town clerk in 1924, a position she held for 30 years.

The Chesbro family sent members to serve in the U.S. armed forces in five different wars. Fred Myron Chesbro, who was born in Fairport, was commissioned a second lieutenant in the U.S. Reserves in 1917 during World War I. He was first sent to Camp Lewis in Washington and was then shipped out to Siberia, where he served until May 1919.

The United States declared war on Germany on April 6, 1917. Even prior to U.S. involvement in the war, local militia were training in southwest Perinton in hillside bunkers that simulated conditions soldiers would face in France. The structures were made of concrete and were 30 feet long and 7 feet high. Soldiers from the 3rd New York National Guard unit in Rochester would travel on the trolley to Bushnell's Basin and walk to the target range for firing practice.

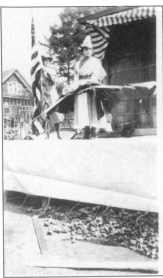

VICTORY LIBERTY LOAN OF 1919
UNITED STATES OF AMERICA

TO · ALL · WHO · SHALL · SEE · THESE · PRESENTS

GREETING, *Be it known that reposing special trust and confidence in the patriotism, fidelity and ability of*

Charles J. Clark

he is hereby appointed and empowered to act as a MEMBER *of the*

Fairport N.Y.

LIBERTY LOAN COMMITTEE

Signed and sealed in the City of New York, State of New York the thirtieth day of March One thousand nine hundred and nineteen, in the One hundred and forty third year of the Independence of the United States.

Governor, Federal Reserve Bank of New York, Chairman, Liberty Loan Committee, Second Federal Reserve District

Beginning in March 1919, Victory Liberty Loan Bonds was the last of bond acts for World War I. Each city was given a quota to meet to help support the war effort and reconstruction. Perinton resident Evelyn Stewart is shown selling V bonds. This form of "pay-as-you-go" fundraising was also used during World War II, when they were called war bonds and victory bonds.

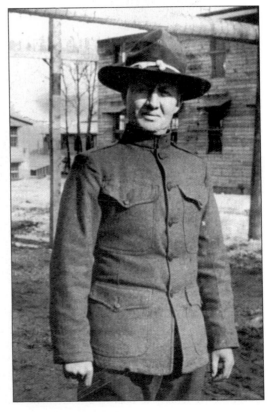

The Brooks-Shepard Post of the American Legion was named for two Fairport men who died in World War I. On February 24, 1918, James Willard Brooks enlisted in the infantry. On June 24, 1918, he was promoted to private first class. He died at Argonne Woods, France, on October 15, 1918, from wounds received and endured when he courageously refused to leave his runner post until his replacement arrived. Brooks is buried in Argonne American Cemetery. Howard Shepard (not pictured) died in October 1918 from wounds received in the battle of the Hindenburg Line.

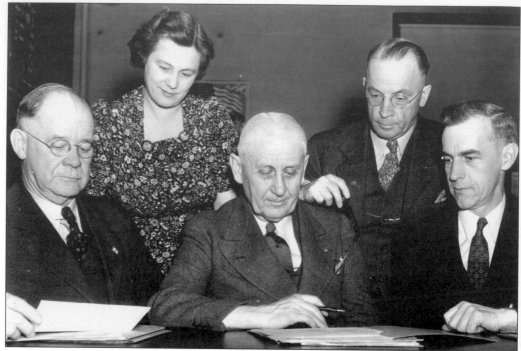

During World War II, Local Selective Service Draft Board No. 561 was responsible for registering men between the ages of 21 and 35 from the towns of Perinton, Penfield, Rush, and Mendon. Draftees, whose numbers were drawn by lottery in Washington, had to report to the local draft boards. The boards determined exemptions based on questionnaires the draftees filled out. The board members shown here are, from left to right, Theodore Zornow, Hazel J. Gurney, W. Dewey Crittenden, Thomas Coffee, and Raymond Fiske.

The first World War II draftee from Fairport was Albert P. DiRisio, generally known as "the Hawk" because of his eyesight. DiRisio was first stationed at Fort Bragg on June 16, 1941. He was made a mess sergeant and served on several fronts. He said afterward, "Heck, I was in three D-Day invasions, not just the one everyone remembers on June 6, 1944." DiRisio accompanied the troops at the first landing in Algeria in 1942, at the invasion of Sicily in 1943, and at Utah Beach during D-Day in 1944.

THE COUNTY OF MONROE
CIVILIAN · PROTECTION

Awards this
CERTIFICATE

To MISS ELECTA GRIFFITH

in grateful appreciation of loyal and patriotic service to country and community during the World War II emergency as a member of the United States Civilian Protection organization.

Given at FAIRPORT *, New York, July 23, 1945*

Clarence A. Smith *Harry F. Van Horn*

The U.S. Civilian Protection organization set up an elaborate warning system for spotting enemy planes and notifying the community. The American Legion Brooks-Shepard Post furnished equipment for an observation post, a cabin built on the Jesse B. Hannan farm. Legion members served in relays beginning in the summer of 1941. After 1943, the Boy Scouts of Troops 207 and 209 manned the day shift. East Rochester citizens watched from a lookout tower erected on top of the high school.

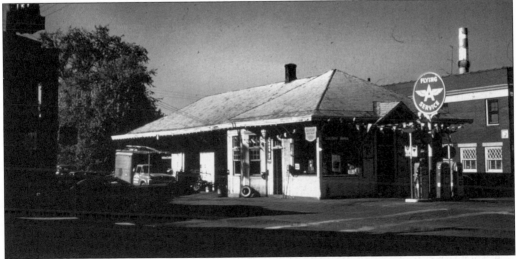

Civilians sacrificed for the war effort in many ways. Not only was gasoline in short supply, but so was rubber. Albert Henry Knapp worked in this Texaco garage (formerly the Rochester, Syracuse, and Eastern trolley station) retreading tires. These machines ran day and night for several years to keep up with demand.

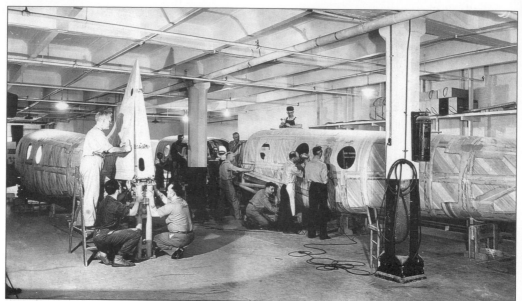

Several local companies won contracts from the armed services to manufacture products for the war effort. The Rochester Fireworks Company, on Whitney Road, made flares for the navy. The Gunlach Manufacturing Company made lenses and cameras for the army, and the Despatch Shop manufactured army locomotive tenders that were sent to the Soviet Union. The men pictured here are constructing airplanes at the piano works in East Rochester.

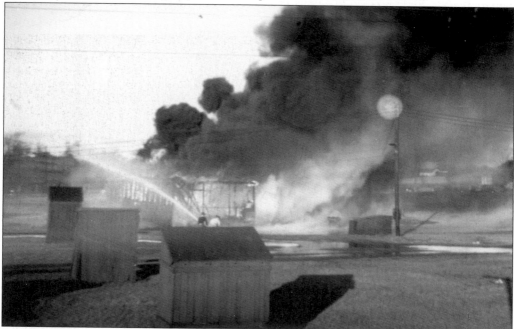

On November 6, 1942, one of the most disastrous fires to occur during the war happened at the Rochester Fireworks Company on Whitney Road. The flash fire started in one of the buildings on the property shortly after the second shift began. Nine people were killed and 10 others were burned before the fire could be brought under control. The existence of 14 escape doors prevented more deaths from occurring.

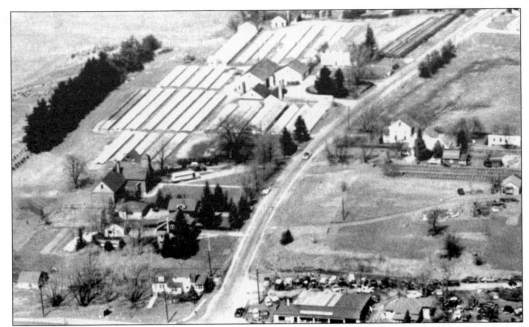

During World War II, German prisoners of war were housed at Cobb's Hill in Rochester and were sent out to various companies to work under guard. In Perinton, prisoners worked at the Fairport Ice Company on Turk Hill Road and at Steffen's Greenhouses on Baird Road, shown here on the left. Businesses could request prisoners of war to work for them only if the jobs did not deprive American citizens of work.

Women made contributions of all kinds to the war effort. Elma Nau Gaffney began as a part-time librarian for the Fairport Public Library in 1933 and worked her way up to director by 1938. Mason Gaffney, her husband, enlisted in the army in 1942 at the age of 46. He died of a heart attack in May 1944. Elma took a leave of absence in 1945 to work in the hospital library at the Treasure Island Base in San Francisco.

After the war, Albert DiRisio (left) used his cooking experience in the army to buy and run Hawk's Hamburgers, at 13 North Main Street in the village of Fairport. He no longer feared shrapnel from mortar shells making holes in his best kitchen pots, as happened once in southern Sicily. A good storyteller, he entertained customers in what became known as Hawk's Restaurant, a popular eatery and fixture of downtown Fairport for many years.

The Perinton Memorial Post 8495 of the Veterans of Foreign Wars was granted a charter by the national organization in 1946. The post home was built at 300 Macedon Center Road in 1948, with 95 charter members. For several years, it was the largest post in Monroe County. Members are shown here honoring a fallen comrade as taps sound for a burial.

Ten

FAIRPORT BEFORE
URBAN RENEWAL

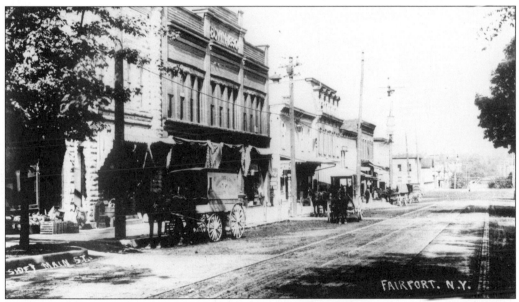

South Main Street has been the traditional business center for Fairport since the early 1800s, when it stood on the edge of a swamp that was later drained for the Erie Canal. The buildings were built and then rebuilt, being transformed from simple wooden structures to more substantial stone and steel ones. By the 1970s, the Fairport Urban Renewal Agency concluded that this commercial district was stagnant and recommended that the area from this section of Main Street to the bridge be torn down and redeveloped.

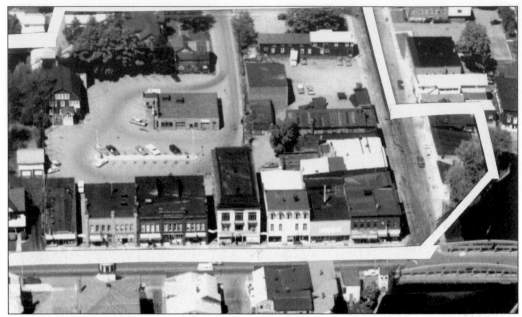

The Housing Act of 1949 created the Urban Redevelopment Agency, which sought out residential and blighted urban areas in the United States for local slum clearance and urban renewal. The "blighted" areas could be condemned, cleared of buildings, and sold for private development. The section outlined in white was slated for demolition, along with several properties to the east of Main Street near the canal.

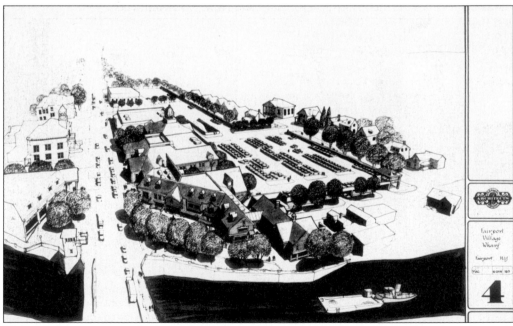

Many plans were considered by the village of Fairport for this new development. An early proposal called for a modern covered mall, a municipal complex, and a 700-foot raised highway spanning the Barge Canal and two railroad crossings. The 1974 proposal shown here, which was never built, has large period buildings, mature trees, and ample parking.

From 1907 to 1975, Bramer's operated in the *c.* 1856 Seeley Block, at the corner of South Main and West Avenue. Upstairs were Bell Telephone and the office of Dr. George Price, who treated injuries after the DeLand Chemical fire in 1893. Hart's (left) was the site of Abishai Goodell's grocery store, possibly Fairport's first. Grocers Goodell and Aiken, and then Saleno and Howe, followed. Fairport's first department store, Snow and Parce, opened in 1883.

The Morey Block was built by joining Smith Morey's home to his pharmacy to the north. Hodkin and Peacock bought the pharmacy in 1865. In the 1880s, the building housed the first public switchboard, with Charles Peacock courteously relaying messages to subscribers and, when necessary, to the other telephone company in town. S. Morey and Sons dry goods store operated at this location for over 75 years before being bought out by Saxton's Department Store.

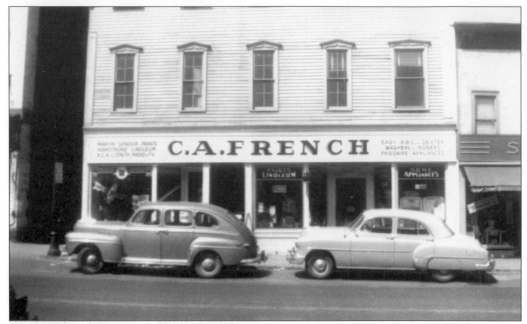

The Ives Block, built *c.* 1870, initially housed silversmith John Ives, a shoe store, and Brant's jewelry store. Hupp's drugstore (1909–1920) started here, and it was then sold to Wagor, which later moved next door into the Bown Block. Charles French bought the building in the 1930s and started French's appliance store. His relative, Jack Lauder, acquired French's, expanded into furniture sales, and reportedly sold out to partner Jerry LaClair before the building was demolished for urban renewal.

Prominent Fairport businessman George Bown (1835–1904) emigrated at age 13 from Canada to live with an uncle in Penfield. In 1856, after marrying Mary Jane Foreman, he and his family moved to Fairport. He opened a blacksmith shop and later a carriage shop next to his home, both of which were destroyed by fire in 1887. With his sons Frank, Gardner, and William, he reestablished his carriage business behind South Main Street, where he employed over 20 men. George built an impressive house at 131 South Main Street and, in 1890, built the Bown Block. Three years after being appointed postmaster, George Bown moved the post office to the first floor of his new building.

Burton Howe was born just south of Fairport in 1833. After graduation, he taught school nearby and clerked at a Fairport general store. He then partnered with Frank Saleno, William P. Hawkins, and, for 25 years, with Byron Kellogg to run his own general store. Howe married Elizabeth Norman of Fairport. He was a 30-year First Baptist Church member and was a church deacon and trustee from 1879 to 1904. Many of his fellow Baptist parishioners shopped at his grocery store, Howe and Kellogg, while the Congregationalists preferred to shop at Dudley's across the street.

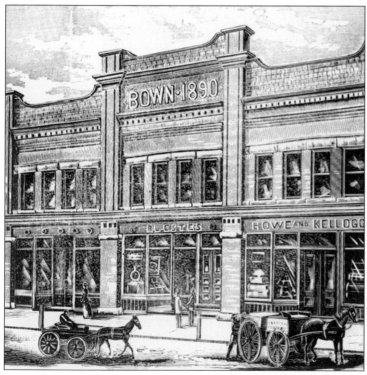

George Bown's block, built in 1890, at one time housed the post office, Howe and Kellogg's grocery, Estes's drugstore and insurance, Warren's groceries, the Howard and Willis dry goods store (formerly Hardick's), a bank, the Fairport Public Library, and the Odd Fellows Hall. It later held Wagor Drugs, the Fairport Department Store, barbers, florists, the YMCA, and the office of Dr. Charles Briggs, who delivered over 1,800 babies in the area. The Wagors reportedly bought the block in the 1960s.

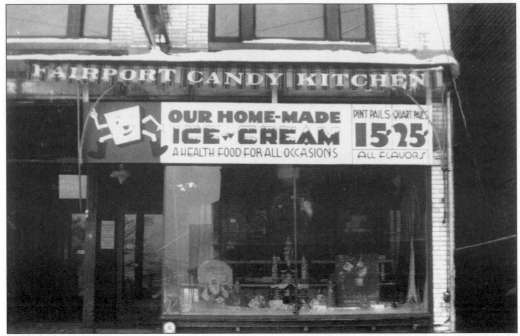

In 1908, Greek immigrant George Varlan started the Fairport Candy Kitchen in the Chadwick Block near the canal, selling homemade candies and ice-cream sodas. In 1911, the business moved to the new Clark Block on South Main Street. This "palace of sweets" had an elegant soda fountain and mirrored walls. Greek employee Nikita Christou and his wife, Florence, bought the business in 1921 and later bought the Clark Block (1938–1967).

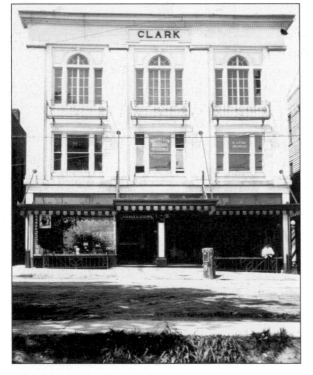

On October 20, 1920, a shootout on South Main Street between a Rochester gang and a group of Fairport citizens killed one man. Sixteen more were jailed. The fight was in retaliation over an incident on the dance floor in the Clark building five nights earlier. C.A. Clark's spacious block, built in 1910–1911, had a third-floor Moose Hall, used for dances, basketball, and lodge and church meetings. It also housed the Hardick store in 1910, the Fairport Candy Kitchen from 1911 to 1961, Nick Messerino's grocery and prime meats in the 1960s, and various other businesses at different times. The Fullam Block, removed from this site to build the Clark Block, housed prominent black citizen Abe Taylor's barbershop and Este's drugstore.

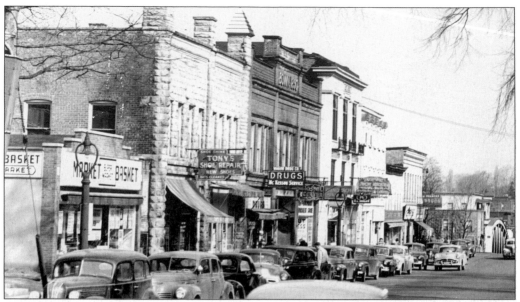

O.C. Adam's castle-fronted block (second from the left) housed his grocery, which sold fresh and salted meats, fish, oysters, seasonal produce, and ice. Grocers Hollander, Terpening, and Cotter followed. From 1937 to 1975, Tony Pittinaro ran Tony's shoes with his brother Frank. Tony later bought the block. Note the Fairport Market Basket on the far left. This spot was originally occupied by the Becker Bank building and, later, by A&P and Fairport Speed Wash.

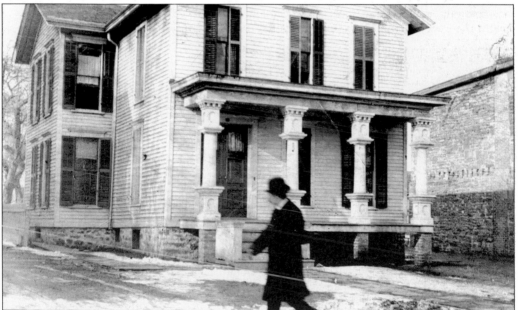

Lorenzo Howard, a blacksmith and a wagon and buggy proprietor in 1841, was an ardent antislavery agitator who helped fleeing slaves on the Underground Railroad. Howard's son Col. Simeon Howard admitted frightened slaves and later fought at Gettysburg, his hat sustaining 30 bullet holes. DeWitt Becker's Private Bank operated here. Despite Becker's reported wealth, investors lost funds due to inadequate records when Becker died. The house was later replaced by an A&P grocery.

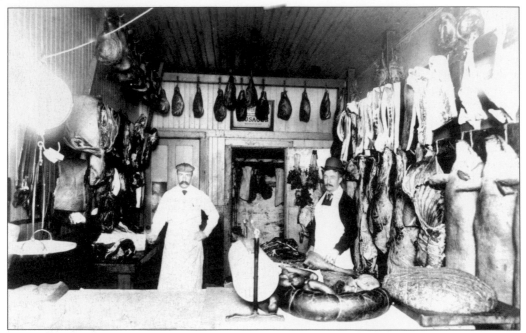

Ernest and Allen Filkins worked at George Filkin's Meat and Grocery Store's meat counter, at 30 South Main Street, *c.* 1900. They later moved their store into a large brick building across the street at 45 South Main Street.

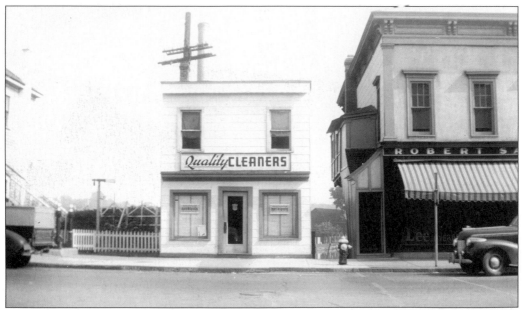

The 1978 Packett's Landing redevelopment required the razing of several eastside South Main Street buildings, including the small Quality Cleaners building south of the lift bridge tower. Eddie Francis's family ran Quality Cleaners from the 1930s to the 1940s, renting the building from owner Robert Sayles, who owned the building next door. Gwen Wagor, an English artist who married into the Wagor Drugs family, briefly rented the building for an art store from Sayles's successors, Seymour and Marilyn Rudin.

In 1908, George Steubing's bakery and ice-cream parlor operated in the Best Block (shown decorated for Old Home Week). The back of the building was reportedly moved here, originally being the "cocoonery" of Abishai Goodell's silk business and later a select school. In the 1800s, Smith Morey and E.L. Dudley's grocery store was here; the second floor was occupied by dentist Willis Trescott. Robert Sayles's fine clothing store operated here from the 1920s to the 1940s, followed by Rudin's, operated by Robert Sayles's nephew Seymour and his wife, Marilyn.

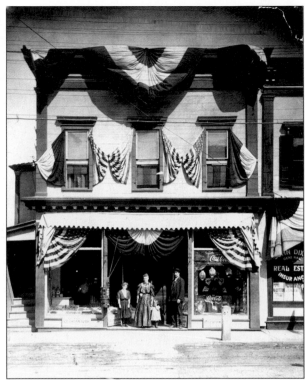

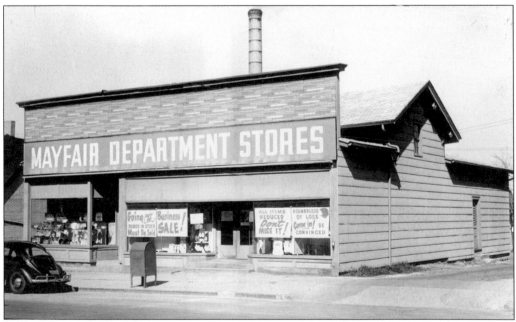

In the 1930s, the flat storefront for Mayfair Department Stores was added to the front of a house (seen in the background). In 1951, this building held Finn's Auto Supply and the Enterprise dime store. Other occupants through the years have been the Perinton Republican headquarters, Market Basket, Slocum's Insurance, the post office, the Urban Renewal Office (1969), and the police station. This photograph was taken by Rev. Albert D'Annunzio.

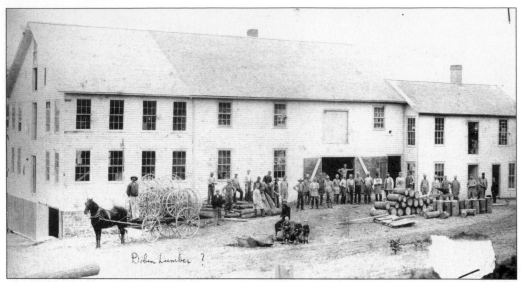

In Fairport, prime business property was found along the Erie Canal. After 1850, Remson Vanderhoof's stonecutting and coal shop and Winne's planing shop, later Loomis's produce business, operated behind the east-side South Main Street businesses. Dobbin and Moore's (1879–1903) coal and lumber business (shown here) received Michigan lumber on canal docks and made standard-sized windows and doors for homes and businesses. Three other lumberyards followed: Fairport Lumber and Coal, Dudley-Hanby Lumber, and Dudley Lumber.

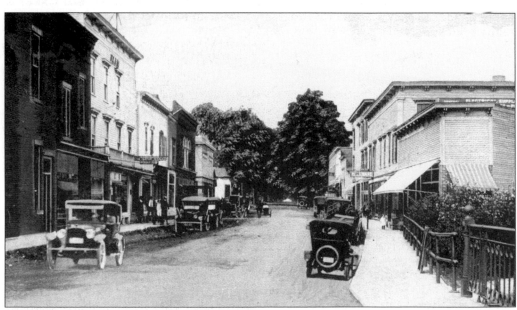

This view of West Avenue, looking west from South Main Street, is from a postcard c. 1910. Before 1850, Fairport had only two streets, Main and Church. Sometime later, Cherry Street was built, later renamed West Avenue after it was extended west c. 1879. All the buildings on the left side of the picture were demolished for urban renewal. The Schummers Block (in the foreground on the right) was razed and replaced with Kennelley Park in the 1970s.

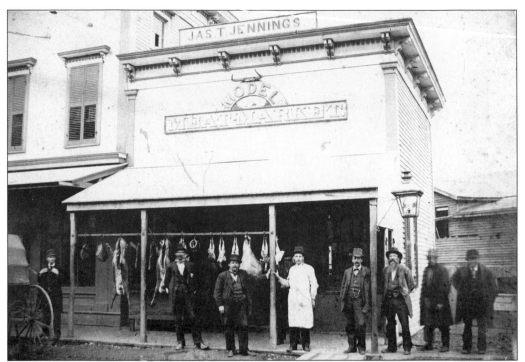

James T. Jennings ran his Model Meat Market out of the eastern section of the Schummers Block. Jennings also owned a fish market across the street, and on Saturday nights, he sold hot dogs and popcorn when the street was closed off for dancing. This section also housed at different times a lunchroom and ice-cream shop, a women's apparel shop, a display room for Fairport Hardware, and a gift shop.

Frederick F. Schummers (1847–1928) was the son-in-law of Jeremiah Chadwick, the most prominent Fairport business leader of his era. Schummers ran his general hardware store in the middle section of the Schummers Block, a three-section building that Chadwick had bequeathed to him. Schummers's son later added an ice-cream and coal business. This section of the block also housed a harness shop, the post office, and a bookshop and pet shop.

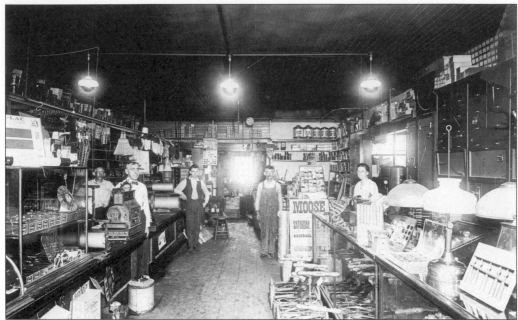

Fred Schummers sold his hardware business and building to John Bahler (second from the left). Bahler sold appliances and had a crew of workmen that did tinsmithing, plumbing, electrical work, and furnace installation and repairs. The store, later known as Fairport Hardware, changed hands several times but stayed in the building until urban renewal.

The westernmost section of Schummers Block, at 26 West Avenue, once housed the village's fire equipment. In 1908, B.J. Woolsey moved his grocery store there and ran it with his son Raymond. B.J. Woolsey lived with his wife in the second-floor apartment. Woolsey's store offered staple and fancy groceries, canned goods, fruits, butter, and fresh eggs. He sold the business in 1919. Thereafter, a series of grocery stores operated out of the building.

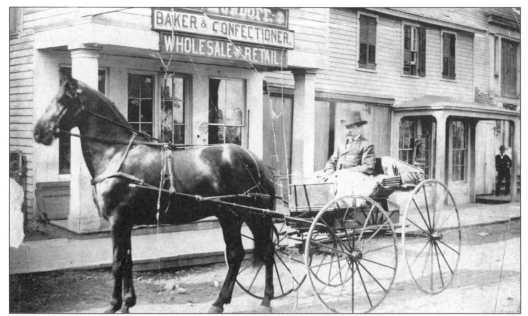

A.F. Murdoff, described as having "enormous walrus mustaches," sold "mechanically-baked" goods from his bakery in the Jerrells Block, at 15–19 West Avenue. He and his family lived in an apartment on the second floor. The third floor was occupied by Mr. Hazen, who made candies and ran what was likely the village's first soda fountain. W.H. Jerrells owned the building and operated a meat market from its east side.

Leander Shaw owned Shaw's Hall, at 23–27 West Avenue, and ran his family's undertaking and livery business in this building *c.* 1870. He was the only undertaker in town and had handled 6,000 burials by 1911. To the right is the Jacobson Block, where Sam Jacobson, a short, dapper man, ran his tailor shop. The building to the far left was the home of the Bryant Printing Shop.

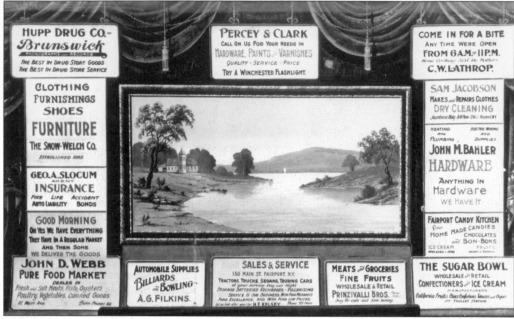

This theater curtain hung in Shaw's Hall in the movie theater on the second floor. At one time, the building was the largest meeting hall in town. The theater was known as Bijou, Bijou Dream, and Rivoli Theater. More than half of the businesses advertising on the curtain were torn down for urban renewal.

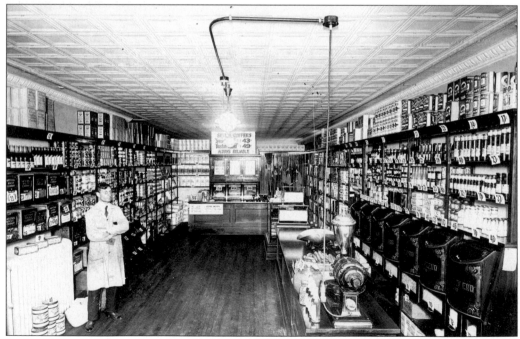

In the 1920s, Burt Copeland managed the Seel Grocery, which operated out of the first floor of Shaw's Hall. Other first-floor businesses included Squire Simmons Insurance, Borlan's Bakery, Hollander & Scovill Grocery, DeKamp's Ice Cream Parlor, Percy Hardware, and Howard Corey Hardware. Al Jensen Hardware and Gerald Williams Hardware later occupied the building.

Not only businesses but also several single-family homes were demolished for urban renewal. This Gothic Revival house at 35 West Avenue was owned by Fred Best, a baker in the late 1890s and early 1900s. The house was later owned by Harland Laird, a truckman and furniture mover.

The village of East Rochester also experienced urban renewal with the destruction of houses and businesses in a block bordered by Main, East Chestnut, Madison, and East Elm Streets. The house known as "the fort" (seen here c. 1908), located on the corner of East Chestnut and Main, was bulldozed to make way for a parking lot for the village shopping mall. The Village Mall opened in the summer of 1974. By 1983, the mall contained mostly small business offices, and the name was changed to the Techniplex Mall.

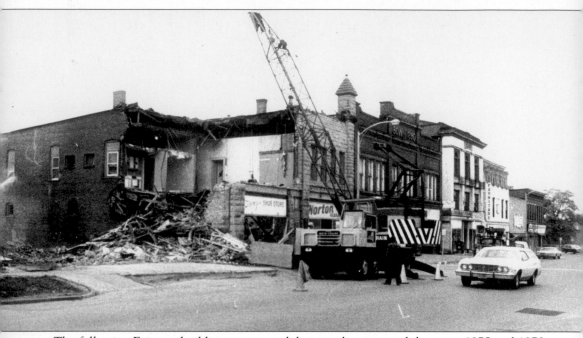

The following Fairport buildings were razed during urban renewal, between 1975 and 1978.

SOUTH MAIN STREET. 2 Bramer's Corner Drug Store; 4 Mabry Insurance and Roger's Barber; 5 Canal Studio Art Gallery; 6 Fairport Village Store; 9 Rudin's Men's and Boy's Wear; 10 C.A. French; 11 Beck Frigidaire; 16 the Christian Book Store; 17 Lake's Antiques; 18 Baron Building, Owens and Keefe Plumbing; 22 Marigold Fairport Inc.; 23 Fairport Urban Renewal Agency, Dudley Lumber (near the canal); 25 Fairport Police Department; 26 Fairport Odd Fellows Lodge No. 536; 28 Wagor's Drug Company; 30 Norton Cleaners; 32 apartments; 34 Tony's Shoe Store; 36 Fairport Speed Wash; Dynamic Optics (in the center of the block); 42 Carmella's Beauty Shop; 52 Wagner House.

WEST AVENUE. 13 Joseph Fiandach, barber; 20 Fairport Hardware; 21 Tropel Company; 23 Jerry Williams Limited; 29 Jacobson Block; 35 Best House, Perinton Motors; 45 vacant; 53 Morreale, Warren and Whitney, dentists.

PERRIN STREET. 3 vacant; 11 Bernard House; 15 Clapp House; 17 Rasbeck House; 21 Woodard House; 23 and 25 DeNardo House.

LEE COURT. 66 Suhr House; houses at 64 and 68.